# PROFESSIONAL
# MARKETING & SELLING
# TECHNIQUES

## FOR DIGITAL WEDDING PHOTOGRAPHERS

### SECOND EDITION

JEFF AND KATHLEEN HAWKINS

AMHERST MEDIA, INC. ■ BUFFALO, NY

**DEDICATION**

This book is dedicated to our friends and family who have inspired us, to our bridal couples who have hired us, to our employees who help us, and to our mentors who have helped educate us. A special thanks goes out to each and every one of you!

**SPECIAL THANKS**

We would also like to take a moment to express our thanks and gratitude to the following people/companies for their contributions to this book: Leah Sabelli; Dan Chuparkoff, software developer and website designer; Christine Perry-Burke; Art Leather; Gross National Product; *Rangefinder*; Lifestyle Publications, LLC; and all of our past bridal couples who are represented in this book.

Publisher: Craig Alesse
Senior Editor/Production Manager: Michelle Perkins
Assistant Editor: Barbara A. Lynch-Johnt

ISBN: 1-58428-180-4
Library of Congress Control Number: 2005926589
Printed in Korea.
10 9 8 7 6 5 4 3 2 1

# CONTENTS

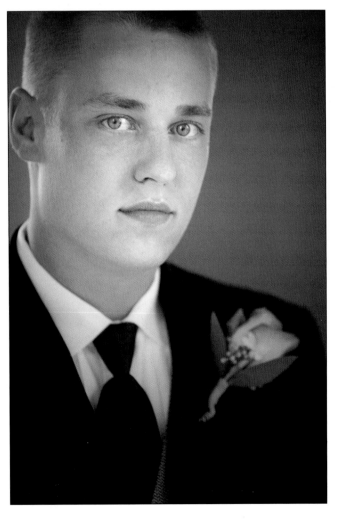

# SET YOUR GOAL

Photography is an art form and a talent that many desire but only few possess. However, successful wedding photography is about more than just cameras and creativity. There is another art involved with being a wedding photographer—the art of successful business and marketing strategies. A photographer with mediocre talents and an incredible marketing and business structure can often become a success. Likewise, a fabulous photographer with an undesirable business plan and unappealing marketing structure may not survive in the marketplace.

This book explores the avenues an amateur photographer can travel to achieve success and embark upon the path from hobby to career. We will also explore the steps required to enhance the journey—and success—of a professional photographer. The first step on this journey is the identification and development of your professional goals.

## ○ DEFINING YOUR GOAL

Once you have elected to pursue the field of wedding photography, you still must identify your marketing demographics and ways to reach the clients you want. First, come up with a plan and a goal. If you don't know where you are going, there is no way to get there. Envisioning the plan can create passion, energy, and make you excited about working to achieve your goal.

IF YOU DON'T KNOW WHERE YOU ARE GOING, THERE IS NO WAY TO GET THERE.

It is vital to create a clear vision. We have all heard the saying, "If you see it, you can believe it." While it may be a cliché, it also happens to be absolutely true. Envisioning yourself as successful will help make it happen. When creating your plan, consider the following guidelines to make tracking your progress easier.

**Commit 100 Percent to the Goal.** As long as you feel as though there may be an out (or an easy contingency plan), you will never truly reach success. Eliminate the thought of returning to the "hobby photographer" category. Plans should be long-range and mapped out for a lifetime and beyond. Have a destination for your business. Create goals for the next five,

ten, fifteen, twenty, and fifty years. Who will be taking over your business? What legacy will you pass on?

**State Your Goal in Writing.** Begin from the future and work your way back. Start with your long-range goals. Let go and dream. Where would you like to be twenty years from now? What do you have to do to get there? Think in detail about how things will be different when you have achieved your goals. See every detail clearly. Be able to feel, touch, hear, taste, and do it! Once you have a long-range goal in mind, work backwards until you have it down to a plan that begins today. This will help you begin to make good choices about your future and business. Putting your goal in writing will also help you uncover any problematic assumptions or hidden obstacles you may inadvertently be creating for your business.

*Envisioning your plans can create passion and make you excited about capturing all the little details on your clients' special day.*

**Create a Business Timeline.** Without a timeline, you have simply created a wish list. Once you have defined the essential tasks necessary to reaching your goals, setting a timeline for accomplishing them makes all the difference. A timeline will allow you to measure your progress and keep you from being sidetracked. This is especially important for photographers, who often find it easier to get caught up in the artistic, rather than business,

aspects of their work. A timeline will keep you focused on your goal and prevent you from spending hours dabbling with a photo-manipulation software program without a true destination or goal.

**Do Not Be Afraid to Take Action.** A business plan can be a very powerful motivator, but taking action is crucial. Do not be afraid to begin the process even before your plan is complete. Detail-oriented photographers may often choose to wait until everything is perfect before stepping forward, but keep in mind that not all the traffic lights will be green on the journey to success. It is important to begin moving forward with caution and critical thinking skills, even while the light is still yellow. It is the passion and desire to reach your identified goal that will help guide you through all the intersections.

KEEP IN MIND THAT NOT ALL THE TRAFFIC LIGHTS WILL BE GREEN ON THE JOURNEY TO SUCCESS.

**Tell Everyone You Know.** Start talking about your plan, your dream, your wishes, and your intentions. Inform your family, your friends, and business associates of your goal. Talk about it like it will happen, and your subconscious mind will help you make it come true. The more you speak about your goals, the more real they become.

## Three Goals I Want to Achieve

In order of their importance to you, list three goals below.

1.
2.
3.

Use the fifteen-point checklist below to evaluate the goals and provide incentives to help yourself achieve them.

1. Do I want it badly?
2. Does this conflict with anything else?
3. Would my family approve?
4. Is it positive?
5. Is it realistic?
6. Did I express it in detail?
7. Is the goal high enough?
8. Do I have the personal qualities needed to achieve it?
9. What short- and long-range goals are needed?
10. Is it written down?
11. Can I make a chart to track my progress?
12. Do I always think positively about myself and my goal(s)?
13. Use a self-reward program.
14. Be prepared for highs and lows.
15. Fill each moment with meaningful action.

**Do Not Forget Your Plan.** Businesspeople generally rely on a plan when their business is starting out or suffering—but they often forget about it once they achieve success. A key factor of a successful plan is remembering that it exists. Reevaluate your goals on a monthly basis and create a daily "things-to-do" list. List your goals in a notebook or on an index card, put them on your refrigerator, or engrave them on a gold plaque. Do whatever it takes to make the plan work for you.

REEVALUATE YOUR GOALS ON A MONTHLY BASIS AND CREATE A DAILY "THINGS-TO-DO" LIST.

With an open mind, an "abundance mentality," and a business plan, we will examine the full-circle concept of wedding photography. First, we will identify your target market. Next, we will discover the difference working full-circle makes. Finally, we will reveal the hidden secrets to completing the cycle, while upping your sales by thousands of dollars.

*Successful wedding photographers know how to combine goal setting and business planning with high-quality photography.*

# TARGET YOUR MARKET

Every day of every year, hundreds of couples begin to make their dreams come true by saying the special words "I do." These couples vary greatly and in many ways—from their financial classifications and national origins, to their age specifications. In order to identify what demographic would be most productive and appropriate to target, photographers must identify their ideal markets. This classification establishes how the photographer will position him- or herself in the community in regards to pricing structure and location. The first step is to clearly define what product you want to produce, who you want to produce the product for, and how you want to promote the product.

## ○ IDENTIFYING THE PRODUCT

We have already established that your primary objective is to target the wedding industry. However, there are different types of products to consider. For instance, wedding albums range widely in style and size. Your company may also choose to provide a variety of framing options or invitation pieces.

Selecting the types of products you want to produce is partly dependent on the type of image you decide to create. There are a wide variety of styles of photographic coverage, ranging from traditional to photojournalistic. While a combination of all three of these styles may be used, your market will typically associate your organization with the one you favor most. The style you become passionate about should be the one you promote most strongly.

A good starting point for learning about the types of products offered by professional wedding photographers is to contact your local branch of the Professional Photographers of America (PPA) or the Wedding and Portrait Photographers International (WPPI). Contact them not only for additional training and education about the different products available but also to register to attend the annual conventions and trade show exhibits sponsored by these organizations. The vendors at these shows can introduce you to new products and help you select the products that will work best for your

THE STYLE YOU BECOME PASSIONATE ABOUT SHOULD BE THE ONE YOU PROMOTE MOST STRONGLY.

*Traditional images, like those shown on this page, reflect only one of of the many styles of wedding photography you may choose to provide to your clients.*

business. Having all the major vendors under one roof can make your search much easier, as well as more efficient and enjoyable.

Selecting products to sell and display must become an ongoing process and part of your long-term business plan. Keep your displays fresh, and work to eliminate any items that look dated. Even though time and money have been spent on these, each year styles and demands change greatly. Stay

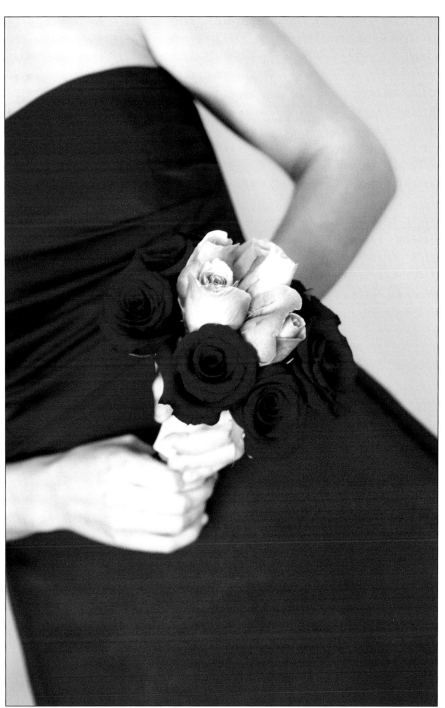

*Images in the photojournalistic style, like the images directly above, are extremely popular among photographers and their clients.*

*Many modern clients prefer the edgier look of photojournalism, or an offshoot of the photo movement called "faux-journalism" (this page and opposite). Photographers working in this style capture less formal, more artistic images and often focus on the emotion of the client or specific, storytelling details of the day.*

on top of the latest trends. Read bridal publications to see what they are promoting to your market, and follow their lead. Brides pay attention to these magazines and will seek out similar styles for their own weddings.

## ○ DEFINING YOUR CLIENT

The products you ultimately select will begin to define the type of client you will attract. For example, more contemporary work, such as black & white photojournalism, often appeals more to a younger demographic. Unless

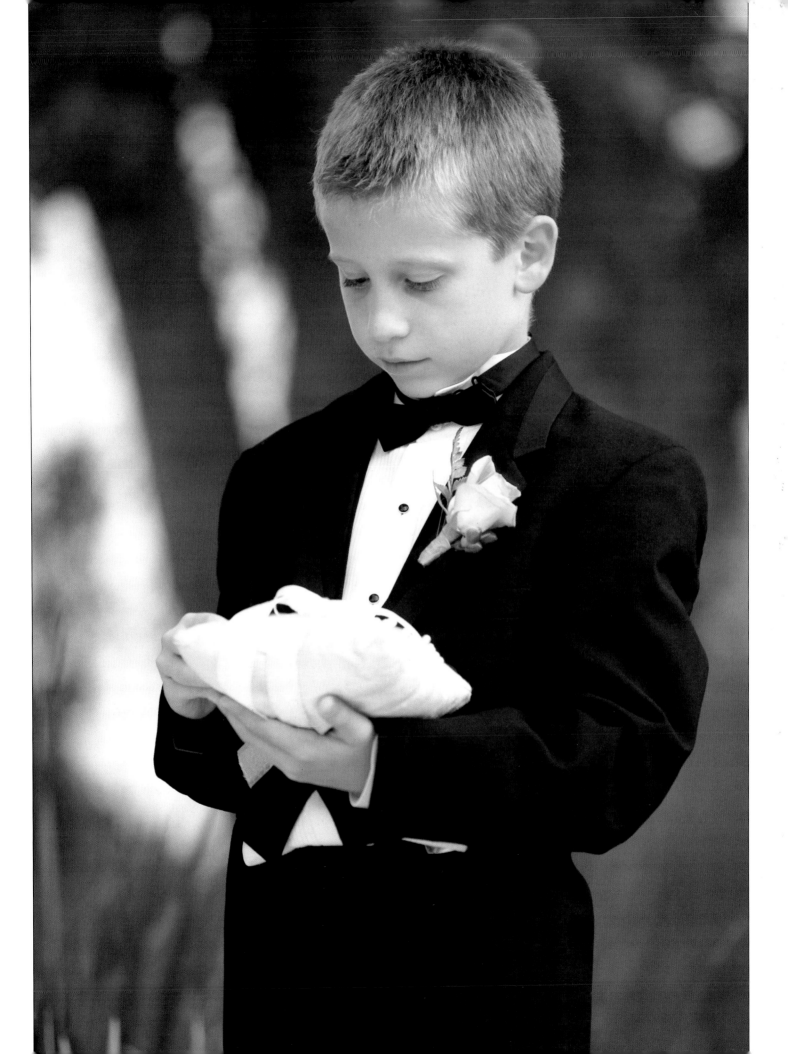

you are content to attract only a very small demographic, your product will need to be more diverse. The safest marketing route is to select not only the products that most appeal to you personally but also a selection of products and images that are designed to appeal to people with a variety of tastes. Showing the full breadth of your style and products will make doing business with you attractive to more clients, while allowing you to maintain your identity.

Keep in mind that there is no right or wrong way to establish your demographic. The choice will be based on the styles you prefer to produce, the area in which you do business, and the people you want to work with. Is your style more contemporary or traditional? Do you live in an urban center or a small seaside town?

Production volume is another area to evaluate. Many very talented photographers target the steady stream of lower-budget weddings and seek a high volume of production in this area. Some photographers choose to seek out a few very upscale weddings. Their production volume may be lower, but they achieve higher returns on each individual wedding. Other businesses fall in between the two extremes. How many weddings are you willing to photograph in a year? How much do you need to earn per wedding to meet your financial goals?

As you ask yourself these questions, compare your answers to your long-term marketing plan. Doing this will allow you to establish the client demographic that is most appropriate for your studio. This classification will determine your promotional strategies.

## ○ BEGINNING YOUR PROMOTIONS

The types of weddings you desire to solicit and the client you wish to target will determine the most desirable location for your studio, the advertising required to attract your demographic, and the pricing position you will require to remain competitive.

**High Volume, Low Budget.** Photographers who choose to shoot a higher volume of lower-budget weddings will generally want to select a high-traffic, lower-cost location. Since location appeal is not as crucial to this type of client as to very upscale clients, positioning the business for visibility is more important than investing in a "prestige" address. Furthermore, photographers who seek out this demographic can also utilize smaller advertising means, such as business-card advertisements or classified advertisements. In addition, the Yellow Pages are a good means of advertising for this type of photographer, because the client is typically shopping for price, not style. This type of coverage is often very successful in "destination" wedding locations such as Hawaii, Orlando, Las Vegas, etc.

As a word of caution: new photographers often begin their business by targeting this market in order to receive name recognition and attain a target audience. However, bear in mind that it can be difficult to escape the

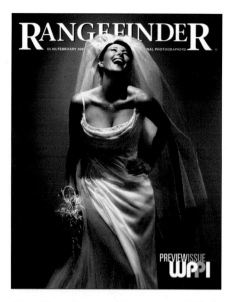

*Reading photo publications will help you remain up to date with trends in the field. Cover reprinted courtesy of Rangefinder Publishing, Inc. Cover photograph by Yervant Zanazanian.*

status and recognition you receive in this category and, through time, this high-volume workload may become very tiring and mundane.

Furthermore, even though this type of service usually requires a lower budget, photographers should never give away their work! The pricing structure you establish affects the entire photography industry and the perception of photography in general. Your pricing structure correlates with your level of competency and your self-esteem. Ultimately, the price you place on your work reflects the way you view it.

**Low Volume, High Budget.** Photographers who choose to target a higher-class clientele and lower volume of weddings typically need to increase their liabilities to target this market. This type of photographer has two choices regarding location: they may select to work in an upscale com-

*Just because you create a commercial studio doesn't mean you can't create a homey appeal.*

mercial location or in a residential gallery. Many photographers who run a residential gallery are very successful. However, if you plan to grow your photography business to include portraiture, note that portrait clients often feel more comfortable in a commercial studio location, especially when there are children involved.

In order for a photographer to target a higher-budget wedding, they must make it their number-one objective to get their images into the community. This can be done through advertising in specific wedding publications, networking with other vendors, and Internet marketing. Yellow Page advertisements are not typically a draw for this target audience.

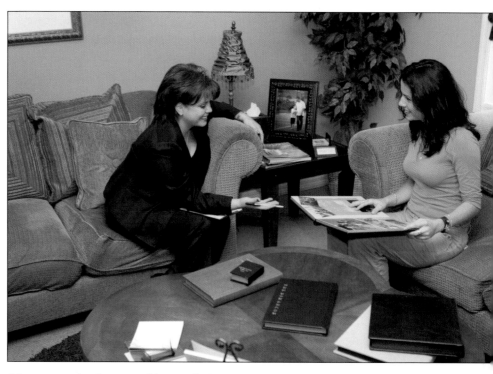

*No matter the demographic you desire to attract or the type of studio you run, be sure to maintain a professional appearance and to ensure client comfort.*

**Combination Volume and Budget.** The last type of business style is the classification that falls in between these two extremes (high volume, low budget and low volume, high budget). This type of business makes up the majority of the photographic enterprises in this industry. These photographers usually examine the pricing strategies of the upscale photographers, then price their work just below theirs. They provide competitive pricing and a level of service that surpasses the quick production-line feeling of the lower-budget wedding photographers.

These businesses can utilize a combination of advertising styles and locations, depending upon which end of the spectrum they elect to target. In addition to the possibility of utilizing a commercial facility or a residential gallery, they may be able to consider other location alternatives to reduce overhead costs. A good starting point for exploring your options for this type of business is to network with other vendors in the wedding industry. Consider teaming up and sharing a facility with one of them. Alternately, consider renting out just a conference area to be used to meet with clients. While all other business can be conducted from your home, this may give you the professional presentation you need, with minimal overhead required.

# Residential vs. Commercial Studios

When deciding between a residential gallery and a commercial property, you should consider the following guidelines:

## RESIDENTIAL GALLERY

A residential gallery is a business you run out of your home (or another home).

### Do's

1. Examine the location. Typically, a subdivision is not appealing to upscale clients—unless it is extremely upscale. The residence should be located near a main road and be easy to find.
2. Rather than working your gallery into your home, select a home that fits around your gallery. Consider your business needs when buying a house.
3. Purchase a home with either a separate entrance, a mother-in-law addition, or a large enough walk-in space to give clients the impression that they have entered a professional gallery.
4. Purchase a home/gallery in a location that allows for environmental portraits (engagement sessions, family portraits, etc.).
5. Invest a portion of the revenue you are saving (by utilizing a residential gallery versus a commercial facility) on advertising to make up for the loss in exposure. Make prospective clients come to you!

### Dont's

1. Set up a residential gallery if you can't keep your family separate from your business. Children and pets can be a distraction and are a turnoff to many people.
2. Allow for havoc and clutter in your gallery. Design your home to meet a level of professionalism and create a first-class impression with your clients.
3. Allow family members to answer your office line in an unprofessional manner.
4. Forget that you do not get a second chance to make a first impression. Even though you are not "going to work," your wardrobe should convey that you are a working professional.
5. Work seven days per week, twenty-four hours a day. Do not allow yourself to burn out. Establish set office hours. Your family will respect your business if you respect your family.

## COMMERCIAL FACILITY

A commercial facility is typically in a mainstream business location with high visibility.

### Do's

1. Plan to spend a lot of money for a first-class, professional facility.
2. Invest in elegant décor.
3. Schedule specific office hours.
4. Invest in property and liability insurance.
5. Consider how easily directions can be given, and whether traffic congestion might deter clients.

### Don'ts

1. Let your family suffer long-term to maintain the caliber of your studio image. Remember why you set this goal and what your priorities are.
2. Invest money in a commercial facility for public exposure and then leave it unattended. Hire a marketing representative to maintain your professional image.

*Once you decide on your target market, the next step is to develop an effective advertising strategy.*

# EFFECTIVE ADVERTISING

How do you achieve name recognition? How do you make your phones ring? How do you get your name on vendor referral lists? What steps can you take toward getting your work displayed in bridal shops, flower shops, and with other affiliates within the wedding industry?

These questions are beneficial to ask and must be thoroughly answered in order to promote your business within the wedding industry. In this section, we will explore several successful promotional strategies, from marketing your business via networking, bridal shows, and Internet access, to publication advertising.

## ○ NETWORKING

Networking is a powerful tool. While it can be a social enterprise, it is also the most cost-effective form of promoting your business. You can begin networking immediately. Here are some helpful techniques that can be used to begin your marketing journey.

**Introduce Yourself to Other Wedding Vendors.** Keep in mind that your image is crucial. Many vendors will gauge your qualifications as a photographer based upon your appearance alone. Dress for success, and dress for where you want to be, not for where you are right now. While certain attire may be viewed as acceptable in the photography industry, people from other fields in the wedding industry may have different expectations. The best approach in selecting networking attire is to attempt to dress a step or two above the vendors with whom you are meeting.

MANY VENDORS WILL GAUGE YOUR QUALIFICATIONS AS A PHOTOGRAPHER BASED UPON YOUR APPEARANCE.

**List Vendors You Aspire to Work With.** You can compile this list by retrieving information from wedding publications, networking organizations, or even the phone book. However, be careful not to become overwhelmed with the number of people and the number of possibilities. Set a goal to contact three new people each week, then plan strategies for developing profitable new relationships with them.

**Join an Organization.** Consider joining a networking organization. Many areas have organizations specifically for wedding professionals, for example, the Wedding Professionals of Central Florida (WPCF). Also, the National Association of Catering Executives (NACE), or the American Bridal Consultant Association (ABC), or even your local Chamber of Commerce have a variety of lead groups and affiliate positions that may be profitable. Remember, just joining the organization is not profitable. You must begin donating time and taking an active role. If you are pressed for time, consider involvement in only one group, then consider volunteering on its board. The more involved you become in the organization, the more likely other members will refer you. As you take on a more authoritative role, you will begin to be viewed as more professional, reliable, and stable. People want to refer people they know they can count on and whom their brides can depend on.

**Find a Mentor.** A photography mentor can be viewed as an advisor or a coach. Maybe it is someone who has an established business, who is viewed as a master photographer, or has experience with judging print competition. A mentor can educate you not only by example but also by giving you many pointers for promoting your business. Observe how they promote their business and watch their behaviors. Learn from their experience and success. You may also be able to develop an effective referral program with local photographers with noncompetitive spirits. Often, a mentor can also refer to you couples who don't fit their demographic or who are looking for a photographer for a date on which they are already booked. Don't be afraid to ask for assistance! Most experienced photographers enjoy sharing their thoughts and expertise.

**Follow Up with the People You Meet.** Don't forget to add these

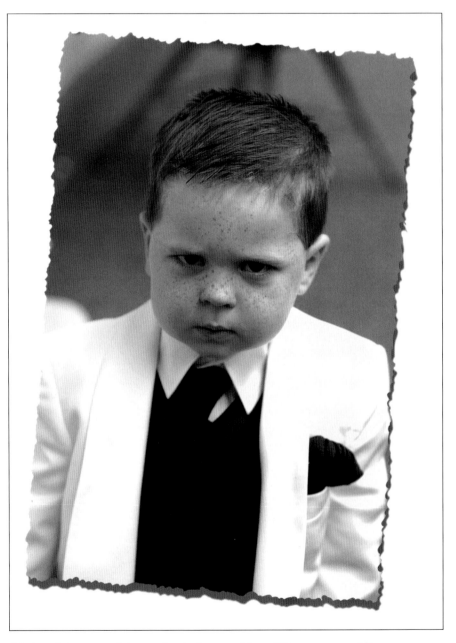

*Maintaining a positive attitude is everything. This young wedding-goer may need to work on that!*

*Hire an experienced web designer who can consistently update your website and optimize your key-word phrases and metatags to make your site as easy to find as possible.*

new business associates to your vendor database. Everyone wears a sign that says "Make me feel special!" so make your meeting with them matter. Send them a thank-you note with a promotional packet after your first meeting. Extend an invitation to visit your gallery and review your portfolio. Also, remember to include them in your holiday promotions and make sure you follow up with them at least once per quarter. Get their e-mail addresses and add them to your e-mail list. It is very easy to send quick updates on company promotions and specials—or even a simple holiday greeting. Do not let them forget you!

**Keep a Positive Attitude.** Your attitude affects the people you associate with. Nobody likes to be around someone with a negative attitude, so stay positive. Affirm what you want and visualize getting it. An affirmation is a statement that helps you visualize what you desire. Visualize being on the top of catering directors' referral lists. You may just end up there!

## O SUCCESSFUL ONLINE MARKETING

How does a photographer capitalize on the rapid expansion of e-commerce and the popularity and effectiveness of an Internet presence?

Let's begin with a typical example. Pretend for a moment that somewhere there is a small wedding photography company. The business owners would definitely want to create a website, because not having one would negatively impact their image and reputation, right? So the proprietors dili-

gently create a small web page with their company name on it, complete with address and phone number. The page might even contain a picture of the crew donning an array of appropriate formal attire, with all their equipment close at hand. (Most small [and some large] company websites look just like the one described here.) They need to select a name for the website, and it just so happens that www.GetWeddingPhotos.com is available, so they register this name as their new website address.

Imagine that there's a young bride in need of a wedding photographer in her metropolitan area. Unsure where to begin her search, she turns to the web. An experienced web surfer, she knows to first head to a popular search engine and type in a few words to get her started. She chooses "wedding" and "photographer" (try this yourself). Fortunately for the small company above, these words appear on the web page that they hastily designed, but according to the search engine, those same words also appear on about 38,300 other web pages. The site www.GetWeddingPhotos.com is somewhere on that list of 38,300.

With a lot of luck and some skillful application of key words (called metatags) that explicitly describe the site's content, it might even appear somewhere in the first 2000 entries. Assuming our bride had the patience to go through several hundred options, she would quickly find that the majority of these websites were for photographers who lived and worked in other states. The moral of the story? Just because you put a website on the Internet does not mean that anyone will ever find it!

Well, our hypothetical wedding photography company learns quickly from its mistakes. In an attempt to solve their "lost website" problem, they opt to place their web address on their business cards and correspondence, so that people can easily get to www.GetWeddingPhotos.com. This is certainly something you should do—it's a great idea. Don't embarrass yourself, however, by handing out a business card featuring your web address, and then having a potential customer find only a one-page site with basic contact information (name, address, phone, etc.). That information was already on your business card. You just wasted their time, and they will repay you by taking their business elsewhere.

According to Dan Chuparkoff, an experienced software developer and website designer, there are five simple "P.I.E.C.E.s" to creating a successful website:

*Purpose*—Define the purpose of the site.
*Identity*—Determine a name for the site.
*Essence*—Choose the content's depth and the frequency of changes.
*Creation*—Design the site with the help of an experienced web designer.
*Enlighten*—Begin to advertise to attract people to your site.

*When you create the perfect image for your target client, you'll ensure that she will refer you to friends and family members who need a photographer.*

*Make it easy for your target clients to find your website, which should employ beautiful, up-to-date images.*

*The task of acquiring customers is broken up into two stages. These two stages are commonly referred to as advertising and sales.*

**Purpose.** The most common mistake made by business owners during website construction is that the purpose of the website is incorrectly gauged. The first question to ask yourself when creating a website is, "What is the purpose of my website?" Whatever your product may be, the answer to this question is, "To get customers."

That much is simple, but it is easy to overlook the fact that the task of acquiring customers is broken up into two stages. These two stages are commonly referred to as advertising and sales. This may seem elementary, but failure to make this distinction is the most common mistake made in business-website development. Making this mistake will lead to wasted money and frustrated customers. The goal of advertising is, naturally, to somehow grab the attention of your potential customers. The goal of sales is, of course, to persuade these potential customers that your product is the best of all the available options. Which of these roles would a website service? Most people answer this question incorrectly.

A website is not an advertising vehicle. Rather, a website should be used as a tool to aid in the closing of a sale. There are many ways to draw people to your website, and some of them will be described in the following paragraphs. This having been said, however, the assumption must be made that there has been some previous interaction between you (or a studio representative) and viewers of your website. There will be a few exceptions to this rule—people who live in your town and want your services, who coincidentally type in exactly the right key words and stumble upon your Internet doorway, for example. As search engines on the web evolve and people become more experienced at performing searches, browsers will become more successful at finding what they are looking for. Unfortunately, as things are, you cannot rely on attracting clients in this way.

THE GOAL OF ADVERTISING IS TO SOMEHOW GRAB THE ATTENTION OF YOUR POTENTIAL CUSTOMERS.

Viewers will most likely have decided to browse your site after:

1. Meeting with you and following your suggestion to check out the site.
2. Viewing an advertisement in a publication or on another website.
3. Making contact with a satisfied customer who recommended your services.

So, whether you design your site yourself or commission a web designer to complete the task, your site's purpose should be clearly defined before you begin creating pages. At the very least, provide examples of your work or let visitors view a calendar of your availability. Ideally, your website should contain a completely painless way for visitors to purchase your product or register for your services while browsing the pages that you have provided. Use your website to give prospective customers information that gets you closer to a sale.

**Identity.** The next step in jumping on the e-commerce bandwagon is coming up with a skillfully chosen name for your website. This is commonly referred to as your "domain name." The most obvious choice for a domain name is one that matches your existing company name. You can find out if a specific domain name is available by going to the website of an accredited registration service. There is a list of accredited services available at www.Internic.net. One of these registration services is www.Register.com. Try surfing over to the Register.com site to see if your own business name is available. If your business name is a registered trade name and it is already held by someone else as a domain name, you may have legal rights to that domain name. You may dispute such conflicts in a manner similar to disputing other trade-name violations.

JUST BECAUSE YOU PUT A WEBSITE ON THE INTERNET DOES NOT MEAN THAT ANYONE WILL EVER FIND IT!

If your first choice of names is unavailable, remember these tips when choosing a different name:

1. You may only use letters, numbers, and the hyphen character (-).
2. Avoid the use of homophones ("by" and "buy," "for" and "four"). These add confusion when passing the site's name along through word of mouth.
3. Keep in mind your company's future growth when choosing a site name. The name www.JeffHawkinsPhotography.com is a good name for a wedding photojournalist's site, but it would be slightly less suitable if used to promote the other consultative wedding services provided by the same business.
4. Somewhere near 99 percent of the words in the English language are already taken, so don't expect your first choice to be available. Be prepared to spend some time looking for a name that isn't already registered.

**Essence.** Here the task becomes more difficult. Determining the depth of your Internet presence can be more important than time spent on design and style. A prospective customer's visit to your website will generally be their second instance of exposure to your company (the first having been an introduction via an advertisement or a personal endorsement of some kind).

Each time you require your target customer to spend time and energy to interact with you, a few more people will get bored, distracted, or will be somehow motivated to go elsewhere. It is important to make sure that your site isn't an added stage in your selling process, without offering a clear benefit to the customer. Before you had a website, prospective clients would typically see your ad in a publication and be prompted to call you. The last thing you want to do is run an ad that instructs the user to check out your website, and then have your website do little more than prompt the user to give you a call for more information.

Create a website that works to bring prospective clients a little closer to buying your product or service. The most important thing to viewers of your site is immediate gratification. People want information immediately. They don't want to wait to meet with you to find answers to their questions. Give viewers of your website as much information as you can possibly provide them. If you have ever received a request from a customer for your portfolio, your biography, or your references, then put these things on your site. If your website has convinced them that your service is the one for them, provide them with the opportunity to purchase or register for your services. This removes the opportunity for them to change their minds while they wait for your e-mail response or a scheduled appointment.

As suggested earlier, creating an online ordering system is the best way to profitably capitalize on the flow of traffic onto your site. For example, you can offer a program in which clients pay a set fee to have their images posted online. This will allow them and their friends and family from around the world to see the proofs and order images. Set a specific price for placing engagement proofs online and an additional price for wedding images. We also suggest that the photographer selection the prints and the length of online visibility. For more information on online ordering, try contacting www.MorePhotos.com, www.MarathonPress.com, or www.EventPix.com. The cost is minimal, and the response can be incredible.

**Creation.** In most cases, you will want the help of a consultative web designer to create an effective Internet presence that results in a positive user-experience and, more importantly, in increased sales. On the other hand, there are many tools available (such as Microsoft's FrontPage) that will allow you to create and design a website on your own. However, in order to add some of the really productive components, like online ordering, online registration, or an automated response system, you will probably benefit from at least consulting an experienced Internet professional. Enlisting the help of a designer will also free you from the pressure of trying to register your own domain name and trying to find a site-hosting service.

CHOOSING A WEB DESIGNER IS A DIFFICULT TASK THAT MAY TAKE SEVERAL ATTEMPTS.

Choosing a web designer is a difficult task that may take several attempts. Depending on the depth of your site's content and the frequency of its changes, the fee for this service can range from just a few hundred dollars to several thousand. If you don't have the benefit of a personal referral, the quickest way to find a web designer is by consulting your local Yellow Pages. A slightly better way is to search for "web designer" using a search engine like www.Yahoo.com. Remember that it's not necessarily required that your designer live in the same city (or even country) as you. Contact with your site creator will most likely be conducted via e-mail and the Internet itself, anyway.

In the experience of professional web designer Dan Chuparkoff, these are the top things to consider when hiring an Internet site designer:

1. Look at the designer's past work.
2. Have them create a low-cost prototype before committing to the entire project.
3. Discuss availability in the future to update information as it changes.
4. Get quotes from several different web designers (they will vary dramatically).

When designing (or when helping to design) your website, keep in mind that a well-planned, easy to navigate website is crucial to creating a pleasant user experience. Keep it simple, using common web standards and conventions. Only use underlined text, for instance, if that text is a link to another page. Users of the Internet have been conditioned to expect certain things to happen when they browse a web page. Capitalize on this fact. People know that when they see a tiny picture (commonly called a "thumbnail"), they can click on it to see that same picture in a larger size. Keep these conventions in mind, but don't compromise your style and expression. Just as you would "dress for success" when meeting with a prospective client, your website should communicate exactly what your own professional appearance would have conveyed to the client in a face-to-face meeting.

Furthermore, remember that images are very important. Bridal couples are visiting your website to see your gallery and view your images. Excessive wording or a cluttered page will quickly bore the reader. Replace excessive wording with the images you choose to promote. Keep in mind that not everyone viewing your site has a modem or a computer that is as fast as yours. Always provide thumbnails to any large images on your site. This will considerably shorten the time it takes for your pages to load.

When you are finally finished with your site's creation, test it on the slowest computer you can find, and with different web browsers. Try to determine if your prospective client would have been patient enough to wait for the whole page to load, and make sure that it loads correctly on all major browsers.

**Enlighten.** Finally, you must spread the word that you have a website and let people know what the site's address is. After all, just because you have a website does not mean that everyone in the world will surf onto it.

Networking and word-of-mouth are still the most effective forms of advertising. Make sure you include your new web address in all of your promotional materials. Place your web address on all of your business cards and letterhead. Make sure you send e-mail messages out to everyone in your address book, informing your friends and family about your site. Also send notifications to the affiliates on your vendor list and consider adding a signature file to all of your e-mail notifications. For instance, add "Visit our website at www.JeffHawkins.com!" to the bottom of all your Internet correspondence.

*Bridal couples have an overwhelming selection to choose from at a bridal show—from cakes and gowns, to music and accessories. It is crucial that your products and services stand out.*

When choosing where to advertise, watch your advertising dollars carefully. Take advantage of free links on related websites to promote your company. In some cases, you can submit your website (and possibly your work), and the partnering site will post your information at no charge. However, some sites negotiate a link exchange. This is where you attach a link on your site, linking them to you and vice versa. We don't personally recommend link exchange, simply because it sends the viewer away from the site rather than keeping them there.

## O BRIDAL SHOWS

Bridal shows can be coordinated as spectacular events. They are showcases of participating wedding vendors from varied locations. They gather together to share ideas and information and to help each couple plan intimate details about their special day. If you plan to participate in bridal shows, be selective about the events. These shows can become costly and time consuming; they may also, however, be the most effective form of advertising for your company.

You can usually learn about upcoming shows from local wedding organizations or by reading area bridal publications. However, be aware that

many of the bridal show coordinators limit the number of photographers able to participate. Review a copy of the bridal publication's bridal-show section as soon as the new book debuts. Contact the coordinators of the shows you wish to participate in, and verify the forms of media advertisement and the number of photographers able to participate. Then, determine when booth selection takes place and the cost involved. If everything meets your approval, place a deposit. Do not delay. Procrastination is never listed as a quality of successful people. Once you have agreed to participate, select a booth location, develop your signature design and décor strategy, and establish your method of marketing.

**Booth Selection.** When selecting your booth, attempt to be one of the first people to get to choose your location. Typically, booth selection is established based upon the registration dates and when deposits were submitted. Determine where the food stations and drink areas will be located. Position your booth in the midst of other popular vendors. Food is always a great highlight in a bridal show arena and is a magnetic attraction. Most people want to experience the food and sample the cakes; therefore, such vendors' displays will draw more traffic to your area. However, apply caution to this selection. Do not get *too* close! Allow for a few booths to be placed in between, so the congestion does not deter people from visiting your booth and viewing your images. Positioning your company a few spaces in front of a catering facility or bakery will allow prospective brides to browse a selection of your work while waiting in line. This also prevents potential problems with spilled fruit punch or sticky fingers damaging your sample albums.

**Design and Décor.** Once you have selected a booth location, begin developing your signature design and décor. Purchase a dolly and a carrying case to hold a cloth backdrop, tables, linens, electrical extension cords, lights to place above your framed images, extra pens, clipboards, table easels for your albums, and any other items you choose to use for your display. Once you gather the materials essential for your display, the bridal show preparation process should become easier. As time goes by, you are not required to change the display as a whole; you will just need to update the images.

When selecting your design and décor, consider the message you are sending with what you select. Strive to create a balance and an even flow. Avoid standing behind a table. The table creates a barrier and is viewed as a defense mechanism. Instead, consider pushing the table up against the wall or requesting two classroom-style tables instead of one large table. Create an L- or T-shaped design within your booth. This will invite people to step inside. You will also be able to fit more people into your booth at one time and display work samples and registration boards all around the table, rather than just in the front. Your goal is to attract people to your booth, not to give them reasons to keep walking. The more comfortable

they feel, the more likely they will be able to see your images and register for more information.

Keep your décor elegant and simple. The majority of the people who attend bridal shows are women; therefore, it is important that your booth appeal to the female market. However, do not overdo the wedding façade or décor. Too many vendors will have that décor, and your objective is to stand out and look different. If the bridal show is supplying pipe-and-drape dividers between the booths, you may wish to hang a colored fabric back-drop up in place of the standard white background. An elegant black back-drop is our personal favorite, but yours should be based on the style of your own work and décor. This will create a unique setting and will make your booth more noticeable to the bridal couples. Additionally, you may wish to place material over the tables prior to setting up your album display.

If you are targeting the most upscale, big-budget brides, you may wish to invest in a double booth space. Double booths give you more room to work with and communicate a successful image to your potential clients, as well as to other participating vendors. A double booth will also allow you to create an area for people to review your work and another area to receive additional information or schedule consultations. When using the double booth approach, place a classroom table with your albums in the section closest to the entrance, and position a round table for mini-consultations on the opposite side. Use the space in between to display your easels.

Regardless of your booth size, utilize a professional sign and a display of albums and images. Your sign is more noticeable when displayed higher, so attempt to hang it on your backdrop or determine how it can be attached to the wall. Do not purchase a vinyl sign or a sign that is larger than three-feet long by one-foot wide. You do not want your sign to detract from the elegance and style of your work. Secondly, select no more than three or four albums to display. The number of albums will be determined by the length and layout of your tables. Do not let your tables get overly crowded. Use tabletop easels to lift your albums up, thus allowing a wider number of prospective clients to view them at once.

Finally, place a variety of your favorite framed images on display. Select images you want to promote and that reflect your style. Pick prints that will intrigue the viewer—dangle a carrot, and make them want to see more. Do not give the impression that you are showing them every good image you have ever created. Purchase quality easels that can comfortably display two framed images at once. Do not display more than five or six images at a time. The number of display images will be determined by the amount of space you are working with. Do not become overzealous—adding too many images will only make the booth appear cluttered. To showcase your work as attractively as possible, take a portable lighting system to attach to your easels. Just don't forget to pack your extension cord!

REGARDLESS OF YOUR BOOTH SIZE, UTILIZE A PROFESSIONAL SIGN AND A DISPLAY OF ALBUMS AND IMAGES.

**Method of Marketing.** With a logistically selected booth space, an elegant display, and effective marketing techniques, a good bridal show can result in a tremendous amount of business for your studio. Because bridal shows may literally have hundreds of brides in attendance, the more assistance you have, the more beneficial the show will be to your business. Consider asking past bridal clients to help you promote your business at the show. You may wish to reward them for their efforts with a custom-framed image from their day or a gift certificate for a family portrait session. Have them bring their wedding albums and share their experiences. Their opinions will often be more compelling than anything you could possibly say. Do coach them not to give out too much essential information. Explain to them that every situation is different and that their day should be discussed privately. Encourage them to have the brides register for more information.

Do not wait for an attendee list—get started right away on your leads. Remember, each bride will leave the show with a bag full of products and a brain full of mush. It will be extremely difficult for them to dig through all their literature and actually remember meeting with you. Therefore, it is imperative to create a contact or registration list. You can avoid requesting their mailing address, if you choose. Recording an address is tedious, and brides often have to write it over and over throughout the day. However, it is important to have them register with some basic information, as seen on the following card.

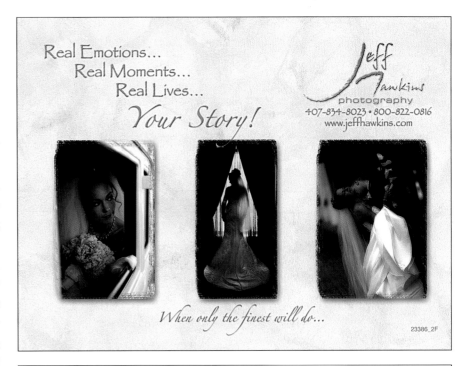

*Marathon's Client Connections software makes preparing, printing, and mailing your marketing pieces easy and cost effective. You can click on the card you would like to use, upload or select an existing database, and click Process—all for pennies a card! Marathon will print, label, stamp, and mail for less than the cost of the postcards alone!*

## Bridal Show 2010

Name _____

Wedding date _____

E-mail address _____

Phone number _____

❏ Yes, I would like to schedule an appointment to visit your gallery.

Within twenty-four hours, jump-start your business. Verify which dates are available for visits, then send an e-mail out to all of the prospects you met. Include your web address in your e-mail; this will serve as a link to your website and make it easier for interested viewers to learn more about your company. Enthusiastically call your prospective clients and schedule visits to your studio. Your clients will not perceive your assertiveness as over-zealous behavior but as a courtesy call. Remember, they told you they wanted more information. You should want to give them a call before your appointments fill up and their date becomes booked.

In conclusion, remember that you never get a second chance to make a first impression. The little things you do will make a big difference. Consider the following:

1. Your image counts. Look your very best!
2. Never chew gum or eat at your table.
3. Try to avoid sitting as much as possible, since sitting creates a passive and disinterested appearance.
4. Keep a positive attitude. Be friendly and courteous. Let the brides do most of the talking. Ask open-ended questions. (See page 39 for tips.)
5. Stay in your booth. Do not chase people down. If they are interested, they will make eye contact. Read their body language.
6. Never talk negatively about another business or vendor in the wedding industry. Respect their differences and value healthy competition.

### O PUBLICATION ADVERTISING

There are many wedding publications in this industry that can assist with getting your name out into the community. These publications have a variety of advertising options that may be profitable in creating community awareness. The type of publication and your marketing demographics will determine the size of your advertisement. Bear in mind that many publications will barter their services in exchange for your services. So, when selecting your advertisement, develop a good relationship with your sales representative and try to barter or negotiate a portion of your payment.

However, advertising alone is not the most effective use of your money. When you place ads, you'll also receive lead lists from those publications (leads generated by the publication via advertising, bridal shows, direct-mail

drops, etc.). Working the lists publications provide is crucial. In these days of electronic media, it is very effective to request your leads via the Internet. To avoid having a large number of leads and not enough time to effectively follow up on them, request that your leads be e-mailed to you on a weekly or biweekly basis. Delete any leads for the dates on which you are no longer available. Narrow your listings, ensure your document contains the clients' names, addresses, e-mail addresses, and phone numbers, and print your document.

Next, prepare an introductory e-mail and leave it in your draft folder. Be sure to include your web address, as this will make it easier for viewers to see your work. If you receive about twenty leads a week, after deleting the dates you are not available, it should only take a few minutes to contact your prospective clients. This places your studio in front of most of your competition.

Lastly, upload your lead list to Marathon Press to have them send promotional postcards as a fast and easy way to get your name and your image in front of your client. Postcards are very efficient since they don't require folding or sealing and cost less to mail than a letter. They also offer more immediate impact (the bride doesn't have to open anything to see your message) and can show the bride another example of your photography.

We do not recommend purchasing the bulk direct-mail package offered by many publications (essentially an automated response to leads from your ad). Separating your mailer from others and creating a superior product will target the discriminating client. However, if you are not investing the time and money in sending out your own response, take advantage of the opportunity and send out theirs! Something is better than nothing.

Consider the following suggestions when placing an advertisement with a bridal publication.

*Consider running ads in publications that do not cater strictly to brides, such as those published by Lifestyle Publications, LLC (www.ReadLifestyle.com). An added benefit: you'll find fewer ads from your competitors.*

1. Avoid hard-to-read or fancy fonts.
2. Avoid excessive wordiness.
3. Analyze the course of action your reader should take.
4. Give the viewer a reason to call.
5. Include a contact name with the phone number. Brides like to know who they are calling. It helps put them at ease.
6. Include a phone number, website, and e-mail address, and be sure that they jump out at the viewer.
7. Brides are visual, so use at least one photo in your ad. Don't be overzealous, and be careful to avoid clutter!

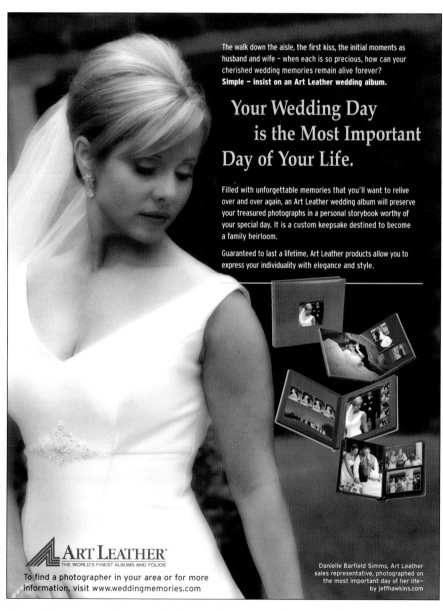

The walk down the aisle, the first kiss, the initial moments as husband and wife – when each is so precious, how can your cherished wedding memories remain alive forever? **Simple – insist on an Art Leather wedding album.**

## Your Wedding Day is the Most Important Day of Your Life.

Filled with unforgettable memories that you'll want to relive over and over again, an ART LEATHER wedding album will preserve your treasured photographs in a personal storybook worthy of your special day. It is a custom keepsake destined to become a family heirloom.

Guaranteed to last a lifetime, Art Leather products allow you to express your individuality with elegance and style.

**ART LEATHER**
THE WORLD'S FINEST ALBUMS AND FOLIOS

To find a photographer in your area or for more information, visit www.weddingmemories.com

Danielle Barfield Simms, Art Leather sales representative, photographed on the most important day of her life— by jeffhawkins.com

*Providing stock photography in exchange for photo credit can mean free nationwide publicity. In this ad, a national photography company used one of our images to advertise the importance of choosing a wedding album.*

## ○ STOCK PHOTOGRAPHY

Finally, take the time to produce stock photography! There are many publications that use images from photographers in different markets, because locals do not submit their own work. Stock photography is considered free advertising—take advantage of the opportunity.

Many photographers say, "I don't know what publishers are looking for!" This obstacle can be overcome by investing a little time and research in the endeavor. Review a copy of a past publication, page by page, to gather ideas. Typically, publications require stock photos for bachelor/bachelorette parties, balloon designs, bridal attire, bridal beauty, bridal gifts/registry, wedding cakes, invitations and accessories, flowers, reception sites, and entertainment/dance.

Submitting these types of photos on a continual basis will get you your free advertising and recognition in the community. It can also make the wedding day more interesting, because you begin to photograph from a different, more broadly targeted perspective.

*At each wedding, look for possible images to shoot and sell as stock photos. Vendors of all wedding industry services (from reception halls, to bakeries, to dress shops) constantly need updated images for their own advertising.*

# INTERVIEW WITH INTEGRITY

Once the lead has been generated, efficient marketing is required to ensure the largest financial gain. Remember, leads equal profit. Poor lead tracking and ineffective lead follow-up can be very hazardous and costly to your business.

There are five top qualities that brides are searching for when hiring their bridal vendors: appearance, qualifications, communication skills, dependability, and critical thinking skills. Become familiar with them and strive to meet your clients' needs during the interviewing process and throughout all interactions with the client.

## O APPEARANCE

As the old cliché goes, "You never get a second chance to make a positive first impression." Your bride will begin to judge you based upon her impressions in the first few seconds of your meeting. She will evaluate the appearance of your literature, the appearance of your studio, the appearance of your bridal show exhibit, your personal appearance, and lastly, the appearance of your work. You will not appeal to a million-dollar bridal market if you are dressed in jeans and a t-shirt—even if you have had a long week! Always remember that your appearance is a form of nonverbal communication. Before disregarding the importance of this, read the following statements, and indicate whether each is true or false.

YOU WILL NOT APPEAL TO A MILLION-DOLLAR BRIDAL MARKET IF YOU ARE DRESSED IN JEANS AND A T-SHIRT.

T/F  As a business owner, how you dress does not reflect the clients you maintain.

T/F  You should never consider with whom you are meeting when you are planning how to dress.

T/F  The time of day should have no bearing on what you wear.

T/F  There's no real need to update your hair and makeup style on a regular basis.

T/F     Because you are an artist, you should always follow fashion trends.

T/F     When selecting casual attire for work you should wear whatever is comfortable or whatever you do on your days off, because you are self-employed.

T/F     Long hair or excessive ungroomed facial hair is well accepted and respected as your artistic preference and will not deter a bride's mother from contracting your services.

T/F     How you print your interview literature is up to you. It is the quality of your photographs that count, not your paperwork.

T/F     The more images you display the better. Regardless of the space size, you want the client to see as much work as possible.

T/F     If you have been in business for a long time and have samples that are old yet dear to you, it is acceptable to continue to showcase them.

If you replied *true* to any of the above questions, your image may be negatively impacting your business. Brides will formulate many different opinions within the first few seconds of meeting you. You are not only selling the quality and the appearance of your images, you are also selling *you!*

## O QUALIFICATIONS

Once a bride feels assured that you are a professional and are not going to scare away her guests, she will begin considering your photographic qualifications. Keep in mind that, to a photographer, "qualifications" are usually technical skills. However, to the average bride who has never been married and has very little knowledge of photography, "qualifications" are based upon the photographer's appearance and a sense that your work reflects the style she is searching for. Most brides will use vendor referrals as a way to measure a photographer's qualifications. The assumption is that if you are referred by someone they trust and respect, you must be qualified. To ensure you are receiving good referrals, you may wish to review the networking section on pages 19–21.

MOST BRIDES WILL USE VENDOR REFERRALS AS A WAY TO MEASURE A PHOTOGRAPHER'S QUALIFICATIONS.

## O COMMUNICATION SKILLS

Speaking is worthless, communicating is priceless. There are two forms of communication—verbal and nonverbal. Verbal communication can be defined as what an individual has to say and how they verbally promote listening with words. Nonverbal communication is speaking and listening with your body language. Either way, when working with your clients, begin by listening. Receive the information your prospective client is sharing before you begin to send your own messages.

In order for an interview to be effective, you must properly send and receive messages. Consider utilizing the following techniques:

**Listening.** *Be Quiet.* Listen without thinking about how you wish to respond. Be sure to allow a few seconds to pass before you respond.

*Maintain Eye Contact.* Making eye contact is a way of acknowledging what someone is saying. It's a documented fact that if you are not looking, you may not hear everything the speaker is saying.

*Use Appropriate Body Language.* Display openness. Do not slouch in your chair—it conveys a carefree attitude. Do not cross your arms and shut yourself off, either. Sit up straight and be attentive.

*To hear actual phone interviews and see three live wedding consultations by Kathleen Hawkins, view the DVD series entitled* Successful Business Strategies, *now available online at www.PhotoVisionVideo.com.*

*Do Not Interrupt.* Do not add your stories or experiences.

*Provide Feedback.* Give the couple feedback by saying things like "oh," "hmm," "okay," or "wow," and nodding your head.

*Restate What the Speaker Has Said.* This lets your clients know you were listening and gives them feedback.

*Don't Fake It.* Don't *pretend* to listen, it will show!

*Determine What the Client Has Said.* Hear and understand their complaints and requests.

*Note Your Clients' Body Language.* Observe the way clients use their bodies as they speak.

**Speaking.** *Don't Judge.* Avoid judging, blaming, or criticizing, especially in regard to another vendor.

*Ask Questions.* Ask open-ended questions, such as: "Do you see the value of hiring a photographer with backup equipment and an assistant?" or "Is there any reason why we couldn't get your paperwork started today?" or "What is most important to you, in regards to the photographer you select?" or "Could you get excited about hiring a photographer who is dependable and high in quality, and having one less stressful thing to worry about on the day of your wedding?"

*Tone of Voice.* Watch your nonverbal message. Watch your tone of voice when you respond to some of the following questions/comments: "I have to discuss this with my parents," or "What kind of cameras do you use?" or perhaps "I have a budget, what are your prices?" Often how you say something says a lot more than the words you are saying—imagine your spouse saying, "No, I am not mad!"

## Be a S.T.A.R.

It is imperative to realize that people are different. Each individual has a different dominant personality type. By discovering what personality traits are dominant in the client and tailoring your approach and interview style to appeal to them, you can be a S.T.A.R. Consider the following four personality types:

### SUPPORTIVE PERSONALITY

The supportive personality wants to keep harmony, peace, and steadiness. They are easygoing and they like to plan ahead. They make great moms and teachers.

    **Type of Interview.** For this interview, you will want to talk slower, be easygoing, and seem more relaxed. These clients will not make a decision until talking it over with their mother and fiance. They will typically book you if others support their decision.

### TASK-ORIENTED PERSONALITY

This personality is detail oriented and conscientious. They are perfectionists and make great accountants.

    **Type of Interview.** Present all the facts. The client will need to review them and make a logical decision. They will probably shop around and take the literature home to compare the products and prices. They will only book you if it appears to be a logical decision.

### ASSERTIVE PERSONALITY

These are dominating, goal-oriented, cut-to-the-chase, get-to-the-point, handle-it people. They make great managers and directors. They are probably in some type of leadership position.

    **Type of Interview.** Don't be offended by the client's directness. Just ask them, "What is important to you in regard to your wedding photography needs?" Wait for their answer, and then reply with facts! If you give them too much information, they will get bored and stop listening. If you offer what they are looking for, they will fill out the contract and pay a deposit that night. They do not waste time in the decision-making process.

### RECOGNITION-ORIENTED PERSONALITY

This person is a communicator and an influencer. They like prizes, recognition, friends, and fun!

    **Type of Interview.** For this interview, let the client talk. Praise them for the work they have done in planning their wedding. Listen to all the details regarding their big day. They have probably been planning this wedding for a lifetime, so make them feel special. If you make them feel important and bond with them as a friend, they will put a deposit down that day.

*Be Prepared for Objections.* Be prepared to overcome clients' possible objections. For example, if you know that money is an obstacle, be prepared to ask them: "How much are you spending on catering?" or "What is the percentage you have set aside for your photography?" or "How important is your photography to you?"

**Dependability.** Dependability is the fourth qualification a bridal couple requires when selecting their photographer. You can overcome this hurdle by offering referrals from past bridal couples or by providing recommendations from other wedding vendors within the community. Nevertheless, the

main task that one can complete to ensure dependability is to simply strive for consistency in dealing with others.

**Critical Thinking Skills.** Solid critical thinking skills are a valuable commodity to anyone in the wedding industry. Critical thinking skills may be judged by the ability to spot assumptions, weigh evidence, separate fact from opinion, and see things from more than one perspective. Critical thinking skills are required when it comes to working with equipment—especially for the wedding photojournalism style. Critical thinking skills are extremely valuable the day of the wedding. Good critical thinking skills will assist in creating good photo relations and public relations on the wedding day. They are also helpful for building mutually profitable relationships with other wedding vendors.

## When Problems Arise

In running a successful business, you encounter clients, customers, employees, and business associates every day. In order to avoid conflict, apply critical thinking techniques to your daily business practices. Unfortunately, times will arise when conflict will occur. For instance, a videographer may interfere with your capture of images on the wedding day, a mother might disagree with your business practices, a client could misinterpret one of your policies, or an employee may create havoc in the workplace. When these problems occur, consider implementing the following practices:

1. Step back and breathe. Don't react with anxiety.
2. Speak up and explain your perspective. Do this in a nonconfrontational manner.
3. Commit to the relationship. You have developed a relationship with the bride. Commit to not interfering in her day! Do your best to solve the problem without getting the bride involved.
4. Refer back to common ground. If dealing with a videographer, remember you are both there for the same reason.
5. Hear their complaint. Listen to their point of view as well.
6. Don't get emotional! Realize cultural (and other) differences may affect the situation.
7. Apologize if needed. This often makes a big difference and relieves stress.
8. If the problem is not solved that day, write a letter. This will help portray your concerns and feelings in a more rational, logical fashion than you would in the heat of the moment.
9. Agree to disagree. Do what it takes to make the best of the situation, and work around obstacles.

## O THE INTERVIEWING PROCESS

Interviewing your clients requires thorough product knowledge, effective communication skills, advanced critical thinking skills, and excellent interpersonal skills. You should implement the previously described communication techniques throughout the interview process described below. When displaying your work, strive to create a benefit so valuable the client cannot afford to go someplace else. Make the clients fall in love with the style of your work, the products you offer, and your studio as a whole.

**Step 1: The Tour.** The sales process begins with a tour of your gallery. Be sure that you have on display contemporary styles in black & white as well as color—photojournalistic or fine art images, for instance. Make your clients fall in love with your images and your custom frames. Show them a wall folio of the intimate details of the day—the back of the dress, the jewelry, the shoes. Show an image with a little hand-tinting or another image-editing effect, just to let them know these options are available. You don't want a bride to go elsewhere, just because she appreciates a look that you don't offer (even if the technique may be slightly passé). As you continue the tour, show them the "mom shots," the more formal, traditionally posed images that everyone needs to do but usually hates doing. An image of the bride and groom alone, or a custom-framed 30x40-inch print of the bridal party, will ease conservative minds and show them that you can provide both cutting-edge and classic styles.

Next, showcase some shots from an engagement portrait session. Grooms usually prefer a session held on location, as it makes them feel more relaxed and at ease. At this time, ask them how they met and how he pro-

MAKE YOUR CLIENTS FALL IN LOVE WITH YOUR IMAGES AND YOUR CUSTOM FRAMES.

*Interviewing your clients begins with a tour of your gallery.*

*During your tour, you should show a full range of work, from engagement portraits to formals of the wedding party.*

posed. They will probably laugh. Nevertheless, once they feel assured your question is genuine and you really want to hear the answer, they will gladly open up and begin to tell you about one of the most important moments in their life.

This is where your bond begins, and your nonverbal listening skills are most important! Listen to what your client is saying. Hear what was magical or important to them and begin to paint a picture with them in it, as you are visualizing yourself conducting their engagement session. Continue painting that picture by displaying a relatively small image of a baby portrait or mother with child. Explain to them that you want to create a relationship with them that lasts a lifetime—not just for their wedding day. Consider offering all of your brides a free baby portrait of their firstborn child—then laugh and remind them that there is no expiration date!

**Step 2: The Consultation.** At this time, take your seat in a nice, cozy area. Select warm, earth-tone colors when decorating your consultation area. This will lower the couple's defense mechanisms and make them feel

cozy and comfortable. Set the mood by playing easy instrumental music, and have tissues (in case your images move them to tears) and expensive wrapped candy available for them. You have initiated a bond and are warming up your client. You should have noticed their responses to the different images and determined what appealed to them the most. You are beginning to identify the product that appeals to them and the type of people they are.

Now, give them a few minutes alone. You have talked enough for a while! Let them warm up to the studio and look at a few albums. Show them different album styles. For example, display a parent album with traditional images to appeal to a traditional mom. Also, select a more contemporary album to showcase

*Create a comfortable atmosphere for your clients and be hospitable. Consider creating a refreshment center and offering beverages upon their arrival.*

photojournalistic images. You may also want to highlight another album to demonstrate a complete storytelling book. The goal is to select a variety of styles, some that are tailored specifically to appeal to the client, and some that will appeal to a wider audience. Be careful not to overwhelm the client with too many albums, though. When a bridal couple spends an excessive amount of time reviewing albums, they stop looking at your photography and start looking at everyone else's work—cakes, shoes, dresses, centerpieces, etc. Your goal is to spend the time bonding with them and selling them on the products and services you have to offer.

**Step 3: Consultation Questionnaire.** At this point, have the couple complete the wedding interview sheet. Make sure that your form requires the couple to enter vital information, including the wedding date, their e-mail addresses, ceremony and reception locations, other photographers visited, and other vendors contracted for their special day. (See the sample form on page 49 for more information).

Begin the interview by discussing the items on their questionnaire. You should already know how they met and how he proposed. Now discover more about their big day. Ask what feel or theme they are planning. If they seem clueless, they are probably just being shy and want to know if your question is sincere. Practice your listening techniques. Visualize what they are imagining. Your objective is to learn whether they are planning a simple

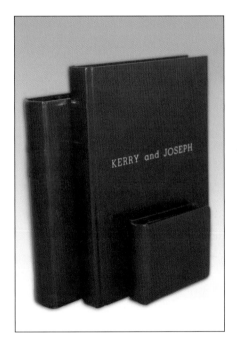

*Showing clients the various album styles that are available is an important part of the consultation.*

It may be easier for a person other than the photographer to do the selling, because it seems more appropriate for them to brag about the photographer's work. As a spouse, employee, or significant other, it seems natural to say "Don't delay! He is awesome and the date won't be available long! I strongly recommend booking today—this way you will have one less thing to worry about!"

There was a time when overcoming objections and closing the sale was the emphasis of an appointment. Today, put the focus on selling you. People buy from people they like, and they will find a way to overcome potential objections if you have created the client connection.

and elegant gala, a fairy-tale event, or the party of the century. This should tell you about the products they need and their personality types. For example, a supportive personality will be very concerned with everyone attending. She will probably not come to the interview alone, and the significant other or parent will be very involved in the planning process. However, the task-oriented personality will have purchased wedding planners and will most likely tell you every detail they have visualized and coordinated. They will also want you to give them a ton of information. Listen carefully, and they will tell you what they want. The assertive personality usually wants something simpler, and not a lot of fluff. Key in to this—you will want to show simple album styles and get straight to the point. Finally, the recognition-oriented personality is most likely to want a true fairy-tale wedding. She has probably dreamed of being the center of attention on this day since she was a little girl and can paint a perfect picture of what her day will be like. Allowing each personality to describe the details of their day will assist in the interviewing process and begin to build a bond of trust between you and your client.

THE ASSERTIVE PERSONALITY USUALLY WANTS SOMETHING SIMPLER, AND NOT A LOT OF FLUFF.

Before selling your prices, products, and services, make a note of the vendors they have hired and the other photographers they have met with already. This will tell you who your competition is and what vendors you may be working with. Be familiar with the vendors and photographers in your area. Knowing the products and prices they offer their clients will give you the upper hand in an interview.

**Step 4: The Interviewing Packet.** Like us, you may find it effective to include two separate sections in the interviewing packet. First, notate your prices separately. We suggest utilizing pricing levels rather than set packages. Unlike a set package where the number of prints in each size is set, a pricing level setup establishes a budget for your client, without requiring that a specific number of images be purchased. Begin by walking the client through their options. Discuss the types of album styles and the prices for

*The interviewing packet contains important information about print sizes, pricing, albums, etc.*

the covers. Next, review the image prices, for example, a 5x5-inch print is $18.00, whereas an 8x10-inch photo is $30.00. Explain to them that it is impossible to guess how many images they will have until after they see their selection. Also, explain to them that the characteristics of each image will determine whether it would be best as a 4x5- or an 8x10-inch print. Our goal is to establish a storybook, not a scrapbook!

After you showcase your products, you should be able to identify what appeals to your client and what type of products they are most interested in

purchasing. At this time, create a pricing level that suits their needs. Your pricing levels should reflect the time you devote to capturing and prepping the client's images, the album design time, and selling. Include a bridal album cover, parent albums, etc. The precise types of products the client will want are established based upon the likes and trends in your marketing demographic. A portion of the total pricing level should be set aside as a product credit. A product credit can be defined as funds set aside on "lay-away" to be used to fill their albums. This is the money that will purchase the 8x10-, 5x7-inch prints, etc. Explain to the client that if they do not utilize their entire product credit it will be refunded, and if they exceed their credit, there will be a balance due. This will ease their minds somewhat in regards to finances and make them feel more comfortable about increasing their photography budget.

Once you have reviewed the available pricing levels, recommend the level that would be most appropriate for the couple based upon the needs they have specified. Inform them that there is a nonrefundable retainer due to secure the photographer's services and lock in the current prices. Use the word "retainer" to indicate that this money is non-refundable. Finally, let the couple know that the retainer is subtracted from the balance due, and that the remaining balance is due the week before the wedding. At that time, you will schedule an appointment to review the allotted times, the participants, and any significant instructions.

**Step 5: The Close.** The most important step in closing the sale is asking for it, and with confidence. First, ask if they have any other questions. If they do not, say, "Great, is there any reason why we couldn't get your paperwork started and give you one less thing to worry about?" If they say no, then shut up—and say no more. Pull out the paperwork, place it in front of them, and say, "Please begin filling out the top half of this form. I will walk you through the rest."

If they are not ready to complete the paperwork, hear the reason why. Sometimes a potential client may be interested in using your services but is concerned about the finances or may feel compelled to discuss it with a family member or friend. Their response may seem negative but is really just a request for more information. Clients need to feel that you understand their concerns and are responding honestly. If you have been listening to their words, watching their body language, and they appear to sincerely like your services, their main objection is probably price. How you respond to the objection will determine how much effort they will put into overcoming the obstacle and using your services. As always, keep the conversation relaxed and positive. Repeat the concern, letting them know that you are paying attention to their needs. Provide them with information that addresses that concern, again, keeping the discussion positive at all times.

*The skills you develop for interviewing should also be used when shooting on their wedding day. Good communication is essential and is an asset in every interaction with your clients.*

## ○ CUSTOMER SERVICE SAVVY

Once you have scheduled an appointment or met with a client, follow up with finesse. Schedule a visit to your studio and, prior to the appointment, e-mail an appointment reminder with directions to your facility.

Send a "thank you for considering us" e-mail after each interview. After a client books your services, send a "don't forget" e-mail or postcard. This is also a good time to send the couple a wedding worksheet, a form that requests basic information such as the names of other vendors the couple selected and a detailed itinerary for their day.

### Review the Process

1. Make the connection between "need" and "benefit." The most effective way to book a client is to personalize the reasons they would want to use your services.
2. Hear their words and their body language.
3. Understand and respond to the different personality types. Learn to be a S.T.A.R.
4. Overcome objections. You must ready for those prospective customers who are reluctant about scheduling a visit to your gallery or about placing a deposit and filling out the paperwork. This is not difficult if you are able to replace a negative thought with a positive one. The formula for handling concerns is as follows:
    a. Relax and be positive.
    b. Repeat the concern.
    c. Respond with solutions that address the concern.

Following up with your clients will create a stronger relationship and ease their anxiety about the big day. Of course, your follow-up efforts shouldn't stop after the wedding. Make it your goal to create a relationship with the couple (and later, their family) that lasts a lifetime.

On the following pages you'll find sample forms and mailers that you can use with your clients prior to the wedding.

# *Wedding Interview Sheet*

**Your Logo**

Today's date _____
Wedding date and day of week _____

## BASIC INFORMATION

Bride's name _____
Occupation _____
Address _____
Home phone number _____
Best time to contact _____
E-mail address _____
Bride's parent's names _____
Which of the following family members will attend the
    event? (please circle)
    mom, dad, brother, sister, grandmother,
    grandfather, stepmom, stepdad

Groom's name _____
Occupation _____
Address _____
Home phone number _____
Best time to contact _____
E-mail address _____
Groom's parent's names _____
Which of the following family members will attend the
    event? (please circle)
    mom, dad, brother, sister, grandmother,
    grandfather, stepmom, stepdad

## THE WEDDING DAY

Where will the bride be getting ready? _____
What time will the bride be ready for photographs? _____
Ceremony location _____ Time _____
Reception location _____ Start time ____ End time ____
How many attendants in your wedding party? Bridesmaids ___ Groomsmen ___ Flower girl ___ Ring bearer ___
How many guests will attend? _____

## THE PHOTOGRAPHY

What is the price range you are considering for your photography? _____
Which photographer would you most like to work with? _____
Can you view images on your computer? _____
Can the parents view images on their computers? _____
Would you prefer to view your images on CD-ROM or DVD? _____
How did you hear about us? _____
Have you seen our website? _____

## THE VENDORS

Please provide the names of the vendors you have contacted for the following services:

Disc jockey _____
Cake _____
Hair/makeup stylist _____
Videographer _____
Flowers _____

Dress _____
Caterer _____
Limousine _____
Coordinator _____
Minister _____

Have you consulted with any other photographers?   yes/no
Who? _____

**Your Logo**

# À la Carte Pricing

## PRINT COLLECTION

| Color Reprints | | Black & White Custom Prints | | Giclee Fine-Art Prints | |
|---|---|---|---|---|---|
| 10x10 | $XX.00 | 10x10 | $XX.00 | 5x7 | $XX.00 |
| 8x8 | $XX.00 | 8x8 | $XX.00 | 8x10 | $XX.00 |
| 8x10 | $XX.00 | 8x10 | $XX.00 | 11x14 watercolor print | $XXX.00 |
| 5x7 | $XX.00 | 5x7 | $XX.00 | 13x19 watercolor print | $XXX.00 |
| 5x5 | $XX.00 | 4x6 | $XX.00 | 11x14 Dekeledge print | $XXX.00 |
| 4x6 | $XX.00 | 5x5 | $XX.00 | 13x19 Dekeledge print | $XXX.00 |
| 3½x 5 | $XX.00 | 3½x5 | $XX.00 | | |
| 8 wallets (one pose) | $XX.00 | 8 wallets (one pose) | $XX.00 | | |
| 48 wallets (one pose) | $XX.00 | 48 wallets (one pose) | $XXX.00 | | |

## ALBUM COLLECTIONS

These stylish, handmade leather, complete with the custom prints of your choice, come with a lifetime guarantee. Custom designs are available.

À la carte bridal albums not purchased pre-wedding day incur a 10-percent price increase. Prices will be based on the current price list. The Master File DVD is not available post–wedding day.

**Designer Bridal Albums**

| | |
|---|---|
| 50-image classic/traditional | $XXXX.00 |
| 75-image basic documentary | $XXXX.00 |
| 150-image deluxe documentary | $XXXX.00 |
| 200-image premier documentary | $XXXX.00 |

**Duplicate Designer Art Book**

| | |
|---|---|
| 11x14 | $XXXX.00 |
| 7x10 | $XXX.00 |
| 5x7 | $XXX.00 |
| Duplicate wallet albums (2) | $XXX.00 |

# Lifetime Portrait Program

**Your Logo**

*The average session fee ranges from $XXX.00 to $XXX.00. Membership in the Lifetime Portrait program is all yours with the purchase of the basic-level album—*
**A $XXXX.00 VALUE!**

Here at Yourtown Photography, we understand the importance of developing lasting relationships with our clients. We don't want to be just your wedding photographer—we want to be your family photographer, too. As one of our bridal couples, you receive an honorary membership in our Lifetime Portrait Program.

You can come to Yourtown Photography at any time, for the rest of your life (or ours) and receive complimentary engagement, formal bridal, baby, family, school, or anniversary sessions and document all the important moments in your life. (Portrait dates, times, and locations are subject to availability. Based on the type of portrait desired, the number of subjects to be photographed, and/or the location requested, a minimum product purchase may be required.)

Whatever that special moment in your life, we want to be there to capture all those precious events.

# *Display and Proofing*

**Your Logo**

## IMAGE REFLECTION DISPLAY

Display the images taken on your special day—using an LCD projector—and entertain your guests during dinner and throughout your event.

When you purchase the basic level album and provide the LCD projector and equipment, we'll provide the display service free of charge—or, if you prefer that we handle the rental, setup, and display, your cost is only $XXX.00.

Alternatively, you can showcase a continuous display of your images on a smaller scale using an SVHS-TV/VCR (if provided by venue), or Yourtown Photography can provide the display on a laptop computer with a 17-inch monitor. This latter option requires no equipment rental and is included, free of charge, when you purchase our basic-level album.

## ONLINE ORDERING

When you purchase our basic-level album, our 20/20 Customer Service Vision program is free of charge. We will upload a minimum of 20 of your wedding images and provide you and your guests with a special web link and private password. To make ordering even easier for your family and friends, you opt to extend the viewing period for an additional 60 days (special price—only $XX.00 [normally $XXX.00])!

## MASTER FILE DVD

Our Master File DVD contains all of your images and allows you to e-mail your cherished photographs to your family and friends. The Master File DVD is also great insurance policy; it allows you to archive your images and rest easily knowing that unlike negatives, your images, on DVD, cannot be scratched or bent. Please be sure to back up your images and make duplicate copies as the DVD is not guaranteed and must be stored properly.)

Our premier Master File DVD is only available when you purchase a deluxe or premier album prior to your event. (Sorry, this special item cannot be purchased separately!)

# Optional Collection

These studio options are designed to complement and upgrade your selected photo package.

### DESIGNER SIGNATURE FRAME

Your beautifully framed portrait greets your guests as they arrive, allowing them to sign in with style. The complete kit includes: the designer frame, signature mat customized with your names and wedding date, one custom 11x14 portrait, and a custom gift box for easy transportation. Frame should be ordered at least 4 to 6 weeks prior to your wedding day.

$XXX.00 (plus shipping)

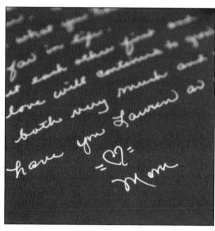

### DESIGNER GUEST BOOK

The artful Designer Guest book allows you to display your engagement session images in a creative fashion. Have your guests sign in style. Black designer book contains 12 images.

$XXX.00

### TINY TREASURES

These Tiny Treasures albums contain 6 images from your wedding day or engagement portrait session. Perfect gifts for any occasion.

Set of 4—$XXX.00

# Digital Retouching

Digital retouching can be used to enhance your images. Our photographer can use artistic techniques to make your images picture perfect.

## PERSONAL ENHANCEMENTS, PRICE PER IMAGE

| | |
|---|---|
| Whitening teeth, brighten the whites of the eyes | $X.00 per head |
| Remove blemishes and simple scaring | $XX.00 per head |
| Lightening dark circles | $XX.00 per head |
| Remove stray hairs | $XX.00 per head |
| Remove eyeglass glare | $XX.00 per head |
| Simple slimming of the body | $XX.00+ per body |
| Remove person | Ask for quote |
| Swap heads, eyes | Ask for quote |

## PRINT ENHANCEMENTS, PRICE PER IMAGE

| | |
|---|---|
| Make image part color and part black & white | $XX.00 |
| Selective focus technique | $XX.00 |
| Watercolor/art technique | $XX.00 |
| Lighting effects | $XX.00 |

Additional artwork will be quoted based on the complexity and time required to complete the requested enhancements and/or corrections.

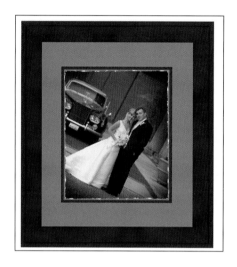

# Custom Framing

**Your Logo**

### RAFAEL DESIGNER FRAMES

Our Rafael Designer collection includes Rafael frame, mounting, floating deckeledged or giclee fine art print, UV protected acrylic, and mounting hardware. Includes our image guarantee.

16x20—$XXXX.00
11x14—$XXXX.00
8x10—$XXX.00

### TUSCANY COLLECTION

Our Tuscany collection includes your choice of designer frame, one of our premier Tuscany collection hand-painted mats with coordinating filet, UV protected acrylic, and mounting hardware. Your fine-art image is included, as is our image guarantee. (Filet upgrades available for a cost of $XX.00 per opening.)

24x30—$XXXX.00    16x20—$XXXX.00
24x24—$XXXX.00    11x14—$XXX.00
20x24—$XXXX.00    8x10—$XXX.00
20x20—$XXXX.00

### DESIGNER COLLECTION

Our Designer collection includes your choice of frame and double coordinating matting. Also included is your prestigious fine-art image, UV protected acrylic, mounting hardware, and guarantee.

24x30—$XXXX.00    16x20—$XXX.00
24x24—$XXXX.00    11x14—$XXX.00
20x24—$XXXX.00    8x10—$XXX.00
20x20—$XXX.00

*Other unique framing options are available . . . ask for details!*

*Sample Forms*

# *Additional Frames*

### CLASSIC WALL FOLIOS

Includes frame, standard double mat, glass, mounting hardware. Available in 16x24, and 12x30-inch frame sizes. These classic frames are designed for multiple images. (Price includes up to 5 images. Additional images can be purchased separately.)

$XXX.00

### PETITE WALL FOLIOS

Available in 15x15-, 10x20-, 9x24-, and 9x16-inch size frames. Many combinations are available. Price includes up to 3 images. Additional images can be purchased separately. (Add $XX.00 per opening for each filet.)

$XXX.00

### DESKART FRAMES

This wonderful frame features a velvet easel back and custom print, and your image is included!

Special offer: Buy 3 get 1 free! Only $XXX.00
(Free frame and image will be up to a 5x7 inches.)

| | | |
|---|---|---|
| Large | (up to 10x10) | $XX.00 |
| Small | (up to 5x7) | $XX.00 |

*Wedding-day frame gifts are available. A 3-frame minimum purchase and 1 month advance notice required.

# Order Form

**Your Logo**

Order date _____
Date to lab _____
Taken by _____

Name _____
Address _____
City _____ State _____ Zip code _____
Home phone _____
Work phone _____
E-mail address _____

| Print Number/Product | Print Size | Quantity | Price |
|---|---|---|---|
| | | | |
| | | | |
| | | | |
| | | | |
| | | | |
| | | | |
| | | | |
| | | | |
| | | | |
| | | | |
| | | | |
| | | | |

## Reprints

| Color | | Black & White | |
|---|---|---|---|
| 10x10 | $XX.00 | 10x10 | $XX.00 |
| 8x10, 8x8 | $XX.00 | 8x10, 8x8 | $XX.00 |
| 4x6, 5x5, 4x5 | $XX.00 | 4x6, 5x5, 4x5 | $XX.00 |
| 3½x5, 4x5 | $XX.00 | 3½x5, 4x5 | $XX.00 |
| 8 wallets | $XX.00 | 8 wallets | $XX.00 |
| 48 wallets | $XX.00 | 48 wallets | $XXX.00 |

\# _____ A M V C

Exp. date _____
Cash

Notes:

Subtotal _____
Wedding clients (10% discount) _____
7% sales tax _____
Shipping and handling _____
Total _____

*I hereby authorize the above work to be done. Payment is due with all orders. I agree that this order is noncancelable. All orders not picked up within 60 days will incur a finance charge of 10% of the total order.*

Signature _____ Date _____

## Your Logo

# Wedding Photography Contract

Engagement sitting _____

Photographer _____

Date of wedding _____

## BASIC INFORMATION

**Bride**

Name _____

Street _____

City _____ State ____ Zip ____

Home phone _____

Work phone _____

Cell phone _____

E-mail address _____

Occupation _____

Date of birth _____

**Groom**

Name _____

Street _____

City _____ State ____ Zip ____

Home phone _____

Work phone _____

Cell phone _____

E-mail address _____

Occupation _____

Date of birth _____

**Bride's parents**

Name _____

Street _____

City _____ State ____ Zip ____

Home phone _____

E-mail address _____

**Groom's parents**

Name _____

Street _____

City _____ State ____ Zip ____

Home phone _____

E-mail address _____

## EVENT INFORMATION

Pre-ceremony photo location _____ Start time _____

Address _____

Ceremony location _____ Start time _____ End time _____

Address _____

Reception location _____ Start time _____ End time _____

Address _____

Relatives in attendance (please circle):

Bride—mom   dad   brother   sister   grandmother   grandfather   stepdad   stepmom

Groom—mom   dad   brother   sister   grandmother   grandfather   stepdad   stepmom

## SERVICES AND PAYMENT

Description of services _____

_____

_____

_____

_____

Subtotal _____

Additions _____

7% sales tax _____

Total due _____

Nonrefundable retainer _____    Date paid _____

Balance due (1 week prior) _____    Date paid _____

I hereby agree to pay the fees required for services, as outlined above:

Signature _____

Date _____

# Agreement for Wedding Photography Coverage

**Your Logo**

This agreement, entered into on _____, is between Yourtown Photography, in the State of _____ and doing business as Yourtown Photography and the undersigned (hereinafter referred to as Client) relating to the wedding of _____ and _____ _____ that will take place on _____ .

_____ Init. SERVICE COVERAGE: The parties agree that Yourtown Photography will furnish the services of professional photographer John Doe and a trained assistant (if needed), who will begin photographic coverage at _____ and continue until _____. The fee for professional services (exclusive of products) and event coverage is $_____. It is agreed that John Doe of Yourtown Photography will be the sole still photographer employed for the wedding day. Simultaneous photographic coverage by another contracted photographer shall release Yourtown Photography from this agreement, and the professional fee will be retained. In addition, we request that guests and professional videographers *not* take pictures of our setup/posed groupings; doing so may delay the process and affect the quality of or ruin your photographs. Due to the fact that weddings are uncontrolled events, we cannot guarantee any specific photograph or pose. We will, however, attempt to honor special requests. In addition, meals must be provided for the photographer and assistant (if applicable) on events lasting over 5 hours.

_____ Init. PAYMENT POLICY and EXPENSES: A fee of $_____ is placed as a retainer herewith to reserve event coverage for the service specified above. This fee is nonrefundable but may be reapplied if the event is rescheduled (subject to availability). A final payment of $_____ will be paid by the Client no later than one week prior to the event, plus reimbursement of applicable airfare, hotel, and transfer expenses incurred by Yourtown Photography in performing the photographic duties expressed herein. This $_____ credit is applied toward the product purchase. Note that *50 percent* of the final purchase price must be paid before we can begin to design your album. Therefore, if your final price exceeds your credit, you will need to submit an additional payment. The remaining balance is due upon approval of the proof. The selection of the bridal album photographs must begin within 2 weeks of viewing the proofs or the album designed layout. *Credits not used within 6 months of receiving the proofing CD will be forfeited. Any contractual modifications to this agreement may be subject to a $XXX.00 service charge.*

_____ Init. PRODUCT PRICING: Pricing is defined on the attached price list. All à la carte prices quoted for professional services, photographs, and products are valid for a period of 2 months following the date of the wedding. Orders placed after 2 months following the wedding are billed at the studio's current published prices, which may be greater.

Signature _____

_____ Init.    LIMITATION OF LIABILITY: While every reasonable effort will be made to produce and deliver outstanding photographs of the wedding events, Yourtown Photography's entire liability to the Client for claim, loss, or injury arising from John Doe's performance is limited to a refund to Client of the amount paid for services. Because this is an uncontrolled event, Yourtown Photography cannot guarantee delivery of any specifically requested image(s). As mentioned above, if our services are cancelled for any reason, the retainer paid to reserve the date is nonrefundable. In the unlikely event of personal illness or other circumstances beyond the control of Yourtown Photography, a substitute photographer of high qualifications, subject to the acceptance by Client prior to the event, may be dispatched by Yourtown Photography to fulfill the obligations of photography herein contracted. In such case that Client declines John Doe's sending of a substitute photographer, Client may elect to terminate this agreement and receive a full refund of all deposits paid to Yourtown Photography. In the event there is a dispute under this contract, the parties agree that the loser will pay the winner reasonable attorneys' fees. The venue shall reside in _____ County, in the State of _____ .

_____ Init.    REVIEW AND SELECTION: Images photographed on the day of the wedding will be digitally captured and recorded on CD/DVD or other media relative to current viewing practices. Federal Copyright Laws protect these images (see below).

_____ Init.    FEDERAL COPYRIGHT LAWS: Yourtown Photography owns all original files, which, unless specified, are not part of any package. We retain the rights to reproduction of any images produced in connection with this agreement. Copying or reproduction in any form (unless released) of any photograph is hereby prohibited and protected under Federal Copyright Laws, and will be enforced to full extent of the law.

_____ Init.    ALBUM ORDERS: Using special design techniques, Yourtown Photography will advise in the layout of the album(s); however, all choices made by the Client will prevail. Album orders will include the photographs selected (with special instruction, if any) following inspection of the captured images. This session will take approximately 2 hours, but could be less or more, depending on the complexity of the design and number of images selected. One design session is included with this agreement. If the client requests an additional design session, a $XXX.00 fee will apply. If additional costs are incurred, financing options may be available. Following notification of the completion of the order, any unpaid balances will be subject to a 2.5% monthly service charge. We are not responsible for albums left unclaimed after 60 days. Items not claimed/picked up after 60 days may be used for stock and studio display purposes, and monies paid will be forfeited. Delivery of the hand-assembled album(s) is ordinarily made within 9 to 12 weeks following the receipt of the order. This time may vary based upon the size and style of the album(s).

_____ Init.    ORDERING REPRINTS: If we are to mail orders, appropriate shipping/handling costs and insurance fees will be charged. We are not liable for loss, damaged product, or mishandled packages. If images are lost/damaged, you must seek remedy from the carrier.

_____ Init.    PROPRIETARY IMAGES: Although Yourtown Photography owns copyrights, negatives, and (unless sold separately) all original photographs taken of the wedding events, any sale, reproduction, publication, or exhibition of any image produced in connection with this agreement, regardless of the ownership of the actual photographs, is prohibited without the mutual consent of the parties to this agreement. By signing this agreement, the client agrees and consents to this fact.

Signature _____

## MODEL RELEASE

Notwithstanding the foregoing, the parties agree that Yourtown Photography may reproduce, publish, or exhibit a judicious selection of such photographs as samples of photographic work to be shown to prospective clients in the form of in-studio displays, advertising, website, and instructional or institutional purposes consistent with the highest standards of taste and judgment.

For the good and valuable consideration, receipt of which is hereby acknowledged, I consent that the photographer, his legal representative, successors, or assigns shall have the absolute right and permission to copyright, publish, use, sell, or assign any photographic portraits of me taken on this or any subsequent dates, whether apart from or in conjunction with my own fictitious name, or thereof, in color or otherwise. Guests should be advised that photographs taken at the event are subject to use in the aforementioned ways.

I hereby release, discharge, and agree to save harmless their legal representative or assigns and all persons acting under the permission or authority or those for whom they are acting, from liability by virtue of any blurring, distorting, alteration, optical illusion, or use in composite form whether intentional or otherwise, which may occur or be produced in the taking of said picture and the publication thereof.

I hereby waive any right that I may have to inspect and/or approve any finished product or the advertising copy that may be used in connection therewith, or the use to which it may be applied.

I hereby warrant that I am of full age and have every right to contract in my own name in the above regard. I state further that I have read the above authorization and release prior to the execution and that I am fully familiar with its contents.

*There are 4 pages to this agreement. Please sign each page.*

Bride ————————————————————— Date ————————————

Groom ———————————————————— Date ————————————

Facsimile signature deemed to be original.

Acceptance of contract terms by the ————————————————————— party.

Studio ———————————————————— Date ————————————

Authorized agent for Yourtown Photography.

Facsimile signature deemed to be original.

# WORK FULL CIRCLE

The second part of the cycle of successful wedding photography is maintaining customer service on the wedding day. You can accomplish this task by implementing public relations in your business. When you add the very important customer service task of maintaining public relations to your photography, you arrive at the full-circle approach to customer service—photo relations! "Photo relations" (like public relations) means maintaining a positive relationship with your clients and the industry through your images and your attitude on the wedding day. Applying your critical thinking and communication skills is paramount in maintaining good photo relations with your clients. However, it is also imperative to create a proactive and unobtrusive style of work on the wedding day, and to deliver images that meet or exceed all of your client's diverse needs and desires.

## ○ PHOTOGRAPHIC STYLE

Being proactive impacts the photographer's photographic style on the day of the wedding, demanding that he have a plan in place for unobtrusively creating beautiful images. There are many needs to balance. For example, while traditional images are vital (most parents do expect them), contemporary brides do not want to spend an excessive amount of time on posed images. Successful album design requires capturing the wedding day with storytelling in mind. As a photographer, you must become passionate about creating a complete album, and not just "getting by" with the required posed images.

SUCCESSFUL ALBUM DESIGN REQUIRES CAPTURING THE WEDDING DAY WITH STORYTELLING IN MIND.

The first step in combining traditional and contemporary styles involves targeting the important elements of the wedding day. These elements include pre-ceremony, ceremony, post-ceremony, and reception photos. The reception should be divided up in these different sections: first dance, toast, cake, garter, bouquet, dancing/fun, and exit. While it is important to photograph these elements in a traditional style with posed images, limiting your time in this area is crucial, since our more modern bride also appreci-

ates the photojournalistic approach. The use of private time can assist in this area as well and will be examined more thoroughly on pages 72–75.

As you endeavor to work full circle on your photo relations, combining styles to create unique images for the needs of each client, you'll find yourself working faster and putting more passion and energy into your photography. Therefore, it is important to have a distinct system in place for capturing each element of the wedding day. Consider the various photo opportunities outlined on page 68.

---

# Equipment Needs

You can begin creating a proactive approach by preparing for the wedding day with backup equipment. A list of our preferred equipment follows:

### CAMERAS
Canon 1Ds Mark II
Canon 20D (3 units)

### LENSES
Canon 70–200mm f/2.8,
Canon 200mm f/1.8,
Canon 28–70mm f/2.8
Canon 17–35mm f/2.8

### FLASHES
Canon 550EX and 580EX (two units)
Quantum T4D (four units)
Metz 60CT-4 with color gels
White Lightning monolights (two units)
1250DR Photogenic flash heads with
    Larson Soff Boxes (four units)

### LIGHT STANDS
Bogen 3078

### RADIO SLAVES
Quantum FreeWires (six units)

### STORAGE MEDIA
1G Lexar CompactFlash cards (six cards)
SanDisk Extreme III

### BATTERIES
Quantum Turbo 2x2 (six units)

### TRIPOD
Bogen 3051 with 3047 head

### COMPUTER EQUIPMENT
- Custom-built Pentium 3 (three units). Production computer has a LaCie Electron Blue III 21-inch monitor.
- Digital Workstation—Pentium 4 3.06 processor with hyperthreading, 2G DDR RAM, 60G hard drives (two units), striped raid 0, 20G scratch drive for Photoshop, Sony Super drive, DVD +/−, GeForce 4 480 8x AGP video card, 19-inch Samsung LCD/portrait/landscape.
- Apple Dual G5 2.5, 4G RAM workstation with a 23-inch flat screen.
- Apple 17-inch PowerBook with 512MB RAM
- 40G Ion gear portable hard drive (FireWire/USB2)
- Server with 1T of storage and a 60G DLT backup tape on a domain controller with 72G storage. Maxtor 250G (two storage units).
- CD/DVD Burners—TDK, Sony DVD Burners, Sony Super Drive
- Monitor Calibration—Pantone ColorVision Optical Spyder
- Printer—HP Color Laser 4500 and Epson 7600 with UltraChrome inks (Epson, Lexjet, and Lumijet papers)
- Graphics Tablet—Wacom 3

---

Photojournalism requires carefully capturing the emotions, the feelings, the intimate details. Look for images that are not traditional. Look for interaction without interacting with your subjects. The minute you start interacting with them, it is no longer photojournalism. Become invisible. Open your eyes and start looking rather than waiting for something to happen.

One mark of a successful photographer is maintaining customer service on the wedding day, unobtrusively creating outstanding images in both classic and more contemporary styles (above). A complete album should show both the joy and romance of the wedding (top left, top right, and opposite page).

## ○ PHOTO OPPORTUNITIES

At the end of this chapter, you'll see samples of album spreads that feature images taken during various phases of the wedding. Creating a strategy to capture images from each phase of the wedding can help you to create a storytelling album that celebrates the uniqueness of each couple and their one-of-a-kind wedding event.

The following is a breakdown of the various phases of the wedding and the photo opportunities you may want to consider. For additional ideas, find a mentor. Study other photographers' work to help create your own unique style. Surf the web and review photography-related websites. Create your own style and your own rules. As long as you keep the storytelling concept in mind, the images will sell. These elements will capture a plenitude of emotions, feeling, and intimacy—creating, at the same time, an abundance of good photo relations!

---

## *Storytelling Moments*

### PRE-WEDDING PREPARATIONS
**Bride**
- House or salon
- Bridal party arriving
- Prior to getting dressed
- Emotions (nervousness, tears of joy, stress)
- Key people (mom, sister, maid of honor)
- Putting on the dress
- Bridal party assisting the bride
- Close-ups of expressions
- Shoes
- Jewelry
- Hair

**Groom**
- Groom's party arriving
- Tuxedos
- Emotions
- Pinning of boutonniere
- Ring bearer
- Marriage license
- Key people (dad, brother, best man)
- Interaction with others
- Posed formals (if time permits)

### BRIDE'S FINAL PREPARATIONS
- Veil
- Flowers
- Dresses (backs, sides, special trim or beading)
- Posed formals (if time permits)
- Final moments
- Bride and dad interacting

### CEREMONY
- Grandparents and parents seating
- Crowd shots
- Entrance of the men
- Expression of the groom as he sees his bride
- Bridesmaids' entrance (try a different angle instead of shots down the aisle)
- Bride's entrance

### POST-CEREMONY
- Bride and groom exiting the church
- Limousine

- Candids of the family and bridal party preparing for the reception
- Table seating cards
- Guest book
- Table shots
- Keep your eyes open for shots that would make good stock images

### FORMALS
- Group shots based upon the time allocated (If possible, allow your assistant to help gather the groupings while you watch the key people for possible photo-journalistic images of expressions and emotions.)

---

*Weddings are not only social events, they are also religious ceremonies! Photographers should respect the sanctity of the events taking place during the ceremony.*

## ○ CEREMONY ETIQUETTE

Upon arrival at the church/ceremony site, observe the lighting conditions, which will vary dramatically from location to location. Continue to keep an eye on the lighting conditions and be ready to adjust as appropriate.

The photographer will want to capture all aspects of the ceremony—for instance: kneeling, the ring exchange, lighting of the unity candle, etc. You should also attempt to obtain an overall shot of the area and the seated guests, if possible. Most churches restrict movement and the use of flash during the ceremony, so keep your movement to a minimum and do not be distracting to the minister or to the guests. The use of a fast lens and high ISO will allow you to cover the ceremony unobtrusively and without flash, allowing you to keep the story line flowing smoothly. By working this way, you will also demonstrate your respect for the sanctity of the ceremony, while still capturing images that will help the couple to remember it.

*At the ceremony, your goal is to capture the moment without getting in the way or causing a distraction.*

## Drag the Shutter

For images at the altar, try dragging the shutter for an exposure of $1/8$ second at f/8. This can be used at just about every church (except for ones with very dark walls or bright spotlights). Your images will take on a whole new look!

*Creating a strategy to capture images from each phase of the wedding can help you to create a storytelling album that celebrates the uniqueness of each couple and their one-of-a-kind wedding event.*

Prior to the ceremony, you may wish to suggest that the bride and groom face each other or the audience when possible to enable more of their faces and expressions to be captured. When creating a storytelling album, it is difficult to sell images of the back of the couple's heads. The tears, the laughter, and the nervous smiles are all priceless moments. A talented photographer is always watching, prepared and ready to capture the glances at the bridal party, or a look at the audience.

## ○ PRIVATE TIME

Meshing traditional and contemporary styles can sometimes be tricky for the photographer and the couple working within a limited time span. However, adopting a "private time" concept can eliminate this hindrance. Private time is usually conducted three hours before the ceremony and can be done with the bride and groom alone, or with the entire family and bridal party. During this time away from the crowds of guests, the photographer can take unobtrusive photographs of the couple, family and/or bridal party interacting naturally.

Before you can sell the private time concept, you must have bought into the idea yourself. If you don't believe in it, your clients won't either. Remember, when selling anything, it is important to build the benefit to the buyer.

**Benefits.** There are many client benefits to choosing to participate in private time. Here are a few that we outline when discussion the option:

- You can use the time alone to pray together.
- Private time allows you some uninterrupted time to discuss what you are about to do.
- With private time, you can spend some time away from the confusion and chaos. You can also freely express your emotions and reduce stress.
- When you allow for private time, you can do all your photographs before the ceremony and get more intimate images. Also, this allows you to spend less time away from friends and family following the ceremony.

*Private time allows the couple to indulge in their emotions and love for each other in private—a real plus on the always hectic wedding day.*

*When the bride and groom see each other for the first time in a more intimate setting than the ceremony, it can be an even more memorable event.*

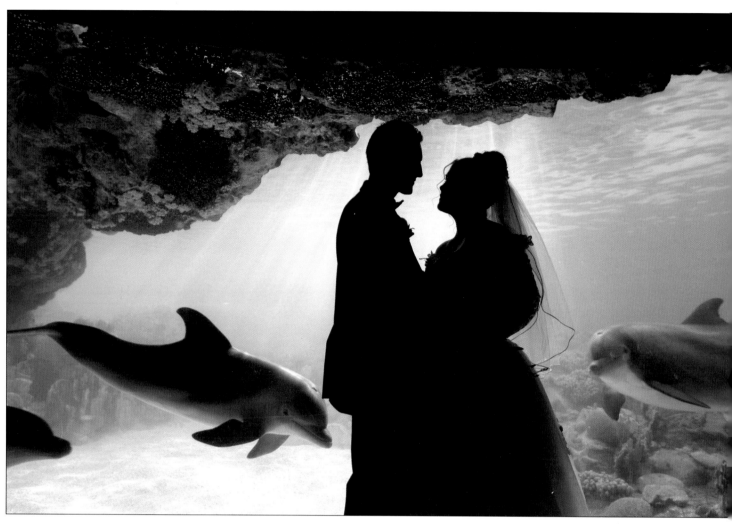

*Private time can be conducted at many creative photographic locations. Encourage your couples to think outside of the box when selecting their private time location!*

**Disadvantages.** The most common objection to private time is from the bride, who wants to see the groom's reaction to seeing her for the first time. To overcome this, use a statement like:

I can understand your wanting to have him see you for the first time—and you, him—at the ceremony. However, we have found that most couples don't even remember that experience. As you are walking down the aisle, the bride often can't even see the groom right away. However, even more importantly, you are usually worried about tripping on your dress or your father stepping on you. The groom typically can't express his emotions, because all he can think about is the hundred people in the church and keeping his cool. With private time, you'll be able to see each other for the first time without all the other stresses, and then spend some very special private time together. You will do much, much more than just gasp as you walk down the aisle.

With private time comes another drawback: couples start their day earlier. When couple raise the objection, you can gently remind them of the bene-

fits of private time and assure them that this time will only create more cherished moments in their very special day.

When private time is scheduled, we select a special private location. When the bride is ready, we stage her holding her bouquet. The groom waits in the corridor (often pacing), until she is ready. Then we ask everyone to leave. The photographer has the bride staged and is positioned discretely in a spot where he can capture both expressions. He then signals on the two-way radios to have the groom enter. The bride's heart starts to pound and the door slowly opens. The groom gasps, and then they hug and kiss. The photographer captures a few quick images as he exits the room.

We are not really sure what goes on in there. Private time is *private*. I have been told they laugh, they cry, they pray. In the past, we have had

WHEN PRIVATE TIME IS SCHEDULED, WE SELECT A SPECIAL, PRIVATE LOCATION.

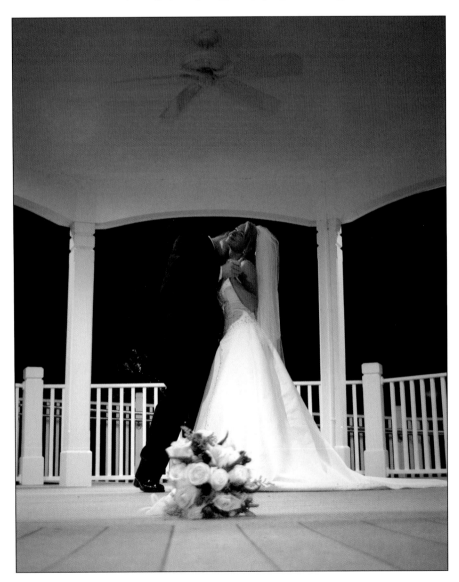

*When the bride and groom are ready, they come out of the private time room, and we begin photographing.*

### Consider this . . .

According to the old adage, it is bad luck for the bride and groom to see each other before the ceremony. However, most churches believe it is good luck to pray together beforehand.

*Private time allows you time to perfect images of the couples both together and separately.*

clients spend as long as an hour together before exiting the room. We have had couples write us thank-you letters stating that their private time was the most special part of the entire day. As we tell couples, you don't do private time to take better photographs, you do private time to have a better wedding day!

When the bride and groom are ready, they come out, and we begin photographing. We usually spend about an hour with them and then have the bridal party meet up with us at the church or other specified location. If possible, we will do the entire posed grouping before the ceremony.

Overall, this service is very advantageous for all parties involved. Using private time allows you to give the client complete coverage and diminishes stress. It also allows you to produce and sell more images. One out of every three weddings we photograph now uses the private time concept. Remember, it can be sold if you are sold on it.

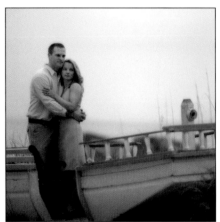

*Encourage couples to schedule an engagement session prior to the special day and build the benefits of capturing their love portrait the day of!*

## O ENGAGEMENT SESSIONS

Engagement sessions are not only financially lucrative but are a great way to strengthen the bond between the photographer and the client by working together prior to the big wedding day! The images the couple selects will tell the photographer the style they most connect with and help determine their most photographic angles and features. Depending on your style of coverage, it can be a traditional engagement session using a backdrop, classic portrait lighting and posing techniques, or it can have more of a fashion or photojournalistic flair. Either way, discuss with the bridal couple prior to the session the wardrobe, location, and props.

Encourage your couples to display their love portrait at their reception. Urge them to consider a designer signature frame, a guestbook, using an engagement photograph in the invitations, or to distribute framed images as bridal party or parent gifts.

*By conducting an engagement session, the couple will see how much fun a session can be—and how easy it is to document their love in a way that suits their unique needs.*

The most effective engagement sessions have been planned and choreographed by both the photographer and the couple. Promote these sessions with all of your couples by creating a Love Portrait checklist, counseling the couple on wardrobe selection and props, and discussing the scheduling requirements in advance.

On the following page, you'll find a sample form that can be used to build the benefits of a Love Portrait with your own clients.

**Your Logo**

# Designing the Perfect Love Portrait

Here at Yourtown Photography, we understand that your Love Portrait will mark the beginning of a new adventure in your life. We will document this special time for you and begin capturing memories that will last a lifetime!

To ensure your portrait is as beautiful as can be, follow these guidelines:

1. Schedule your portrait a minimum of 6 to 8 weeks prior to your wedding day. The sooner the better! This allows adequate time for the lab to process your prints.

2. Choose outfits that suit your personality and make you feel attractive. Make sure that that the color of the garments you select harmonize and that the style of both outfits is well-coordinated. Please do not wear short skirts or shorts, as they make posing more difficult. Long, flowing dresses and jeans or khaki pants are better choices.

3. Start thinking about props; they can make your Love Portrait unique. Consider a picnic basket with a blanket and a couple of wine glasses. Other options include musical instruments and pets. Also consider larger props like motorcycles, cars, and boats.

4. Don't worry about the location. Once you have set your appointment and selected your clothing, we will discuss location options with you. We have access to many secret hideaways. Just tell us what you envision, and we will do the rest.

5. Open your eyes to interesting photo opportunities. Browse through romantic postcards, paintings, and magazine advertisements. We can often re-create such images with you as the subjects!

6. Keep in mind that the Love Portrait is often displayed at the reception (consider a signature frame to allow guests to add a personalized message!). Many couples also include their Love Portrait in their wedding invitations or use framed portraits as party favors or bridal party gifts.

7. If you have a friend or family member you would like a portrait of, bring them to your Love Portrait session. We can easily turn a single sitting into a multiple-client one. Please inform us as to whether you'll be inviting anyone along to the session when you schedule your appointment.

8. Relax and have fun!

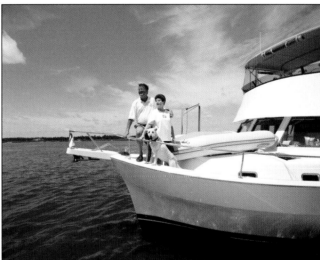

*Arranging an engagement portrait prior to the wedding day gives you an opportunity to work with the couple ahead of time but also catches them when their enthusiasm and cash flow are at their highest.*

Jasen

Rhiannon

*Couples put a lot of effort into making sure all of the details of their wedding are perfect. Take images that capture all of these aspects to preserve their memories.*

# COMPLETE THE CYCLE

Proficiently completing the sales cycle will help make the most of your investment of time and money. As a professional, you invest in advertising and other applicable expenses, but most of all you invest yourself and your time. Making the most of all these investments is very worthwhile. This task can be accomplished by dynamic album design techniques, a compelling focus on frame sales, and successful online ordering promotion and publicity.

## ○ ALBUM DESIGN PROOFING

There are many different approaches to album design proofing. You can use standard paper proofing, printed proofing booklets, CD proofing, or online proofing. When getting started, it's a good idea to get suggestions from your mentors. Don't get stuck in the "fear of change" mode! As technology advances, a successful business owner should grow with the technology. A productive album design system can increase your profits, encourage the sale of double album sets, and expedite the album design process.

AS TECHNOLOGY ADVANCES, A SUCCESSFUL BUSINESS OWNER SHOULD GROW WITH THE TECHNOLOGY.

In our studio, we use CD proofing and online ordering. CD proofing is a system that saves the studio both time and money. To begin this process, we produce a series of Artist's Choice images—photos that are artfully mastered with photo-editing software to achieve our "studio look." We upload a selection of these to our website to give clients a sneak peak at their images and encourage them to schedule a visit to the studio to complete the image-selection process.

During the proofing session, we present the images on an LCD projector, aided by ProSelect's presentation and sales software, a tool that allows us to show images in black & white or sepia and in various sizes. (This software also allows you to project your images and layouts at real size, upsize or downsize them, compare photographs, design multi-image layouts, and collect orders! Visit www.TimeExposure.com for more information or to demo the software.)

After they make their initial selections, we run through the images again to fine-tune their choices. The proof process can be completed a couple of days after the event and only takes about an hour. At the conclusion of the album design session, the couple will be able to upload all their images online (complimentary for thirty days) or only the images they selected for their album. This allows for greater outside sales from friends and family members and increases traffic to our website. In addition, the couple will receive a proofing CD to take home and share with their family and friends.

**Local Clients.** While the couple is still on their honeymoon, and the excitement of the wedding day is still fresh in their minds, we send them a link to our website so they can sneak a peek at the images from their special day and place their orders online. We encourage them to give us a call as soon as they return from their getaway.

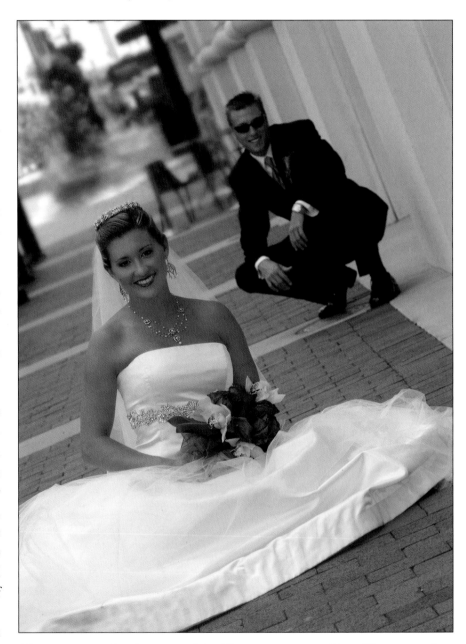

When the album design appointment is scheduled, we ask, "How is married life? Did you have a great honeymoon?" After listening to the client's response, we continue, "Fabulous! I imagine you are excited to see these fantastic images, so let's schedule a time to get together as soon as possible." We then explain that the couple will need to allocate one to two hours for the in-studio private viewing.

The private viewing session is held in our viewing room—a carefully lit and temperature-controlled space. We always offer the clients refreshments, too, to ensure our clients are comfortable and relaxed. This first viewing is done by the couple alone, allowing them to share their intimate thoughts and feelings as they recall the events of their day.

Next, we come in and coach them through the basic design rules and procedures. We ask for special requests like background prefer-

*You can use services from www.MorePhotos.com or www.EventPix.com to place images online and allow the couple to quickly and easily share images with family and friends.*

*At the conclusion of the album design session, the couple will be able to upload all their images online (complimentary for thirty days) or only the images they selected for their album.*

ences, design styles they like and dislike, and ask them to star the images they just love! We run through the list a second and final time, giving the couple the ability to review their selections with our guidance. During this session, the couple can also select their album cover and make other design requests.

Finally, we add up the number of images selected and compare it with the number of images they prepurchased. If they exceeded their images, we tell them what the payment would be if they used all the images they selected. If they didn't meet the number of images they prepurchased, we explain that we may need to add images to enhance the design and the story. Of course, if they decide to go with fewer images, we show them how we can run their images larger, making the album pages appear less cluttered. We show them an album style with fewer images on a page and one with more collage pages. We explain that an image of a shoe will not be represented as an 8x10-inch print in the album and an image of a bridal party would need to be larger than 3x5 inches. We let them know that we have years of experience designing albums and will take their requests into consideration when creating their perfect heirloom album.

We then design their album and place a proof online for their review. Upon review, they can request changes or approve the design as is. The following guidelines are used to help the clients work through the online proofing process:

1. Carefully review your album for accuracy (spelling, dates, etc.).
2. Review your book and approve the image selection and layout choic-

*Images that capture the details of the wedding event are cherished additions to every wedding album.*

es. The pages are shown as spreads (two pages equal one spread), so deletions have to be done in pairs of two pages. If you deleted half a spread, the whole album design would shift, and a redesign would be required.

3. You don't have to determine how to fix anything, just let me know what concerns you. It may be best to discuss your concerns over the phone. This way, we can provide our thoughts on the design process. Keep in mind that any extensive changes made at this point may incur a fee ($10 for image-modification, or a redesign fee, the cost of which is determined by the designer and based on the number of and extent of the requested modifications.

4. Verify that the album cover style and imprinting are correct.

5. Please get back to us within five days to avoid a delay. The album proof will stay online for ten days.

After explaining the above process to the bride over the phone (explain in as much or as little detail as you feel is necessary) get some verbal feedback

*An image like this close-up of the couple (facing page) makes a good cameo or cutout image on the cover of a more traditional album. A classy presentation of the proofing CD (above) assures your clients of your top-notch customer service and studio image.*

and schedule an appointment. Listed below are some hypothetical questions and responses that will help you to schedule a mutually beneficial time for the album design session.

> *Photographer:* So, what is best for you—morning, afternoon, or evening?
>
> *Bride:* (record her response)
>
> *Photographer:* The beginning of the week or the end of the week?
>
> *Bride:* The weekends would be best.
>
> *Photographer:* Well, you know, Saturdays are very busy for us, and Sundays are typically our only day off, so if it has to be a weekend, our next morning opening isn't until _____. I would hate for you to wait that long to view your images. Could you and your husband leave work a little early on a Friday afternoon?
>
> *Bride:* The evening is best, beginning of the week.
>
> *Photographer:* Great! What is the earliest time you can be here? How about Monday, the 14th at 5:30pm?
>
> *Bride:* I don't think we can be there until 7:00pm.
>
> *Photographer:* We need to make it a little earlier. We have found that the later you arrive, the more tired you get, and you just can't design a quality album. After all, you want to be at your best. This is a family heirloom that will be passed down for generations. Is there any way you can talk to your husband and see if you can adjust your schedules to be here by 6:00pm?

**Out-of-Town Clients.** Once the proofing CD/DVD is complete, we send a CD with instructions and upload all the images to the website. We contact the couple by mail, e-mail, and by phone to inform them about the design process and to expedite the production phase.

Because of the sheer number of wedding images, viewers who have a computer with a slow processor or who have a dial-up Internet connection may have trouble viewing images online.

While your methods and equipment may be high tech, keep in mind that your audience may not have access to higher-end technologies. Keep your clients'/viewers' needs in mind when you determine how you want to handle proofing.

A series of sample cover letters follows. The first (page 96) is sent to out-of-town clients along with paper proofs. The second (page 97) letter is sent to couples who have selected far more images than they prepurchased. The letter on pages 98–99 outlines the steps out-of-town clients will take to approve/modify the album design and get their order processed.

We'll take a look at the specific steps involved in creating stand-out albums later in this chapter.

*Your Logo*

November 25, 2010

Dear John and Sarah,

We have designed what we consider to be the perfect studio album for you. Enclosed, you will find a printout of your album, as well as a CD that contains a digital file of the album layout.

With the basic album design complete, you can review the image selection and design concept and modify it to suit your personality and taste. This saves you the worry and hassle of trying to design your heirloom album—after all, we have more design experience than most of our couples—but allows you to ensure that your album fulfills all of your expectations.

We've developed a list of points to consider as you review your album design.

1. The enclosed printout features small (thumbnail) images. Please use your CD, if needed, to see a closer view of the images.
2. Keep in mind that it's our goal to create a nontraditional album. We have chosen images that tell a story and have organized them in a way that takes viewers from start to finish, chronicling the special moments of your unique wedding day. Note that some of the images contained in the design play a role in telling the story. Keep this in mind when you desire to make changes to your album.
3. If you desire to make any changes to your album, please contact us by phone. You can reach us at 1.800.123.4567 to discuss the details.

I am sure you will be delighted with your album—the images are fabulous!

Sincerely,
John Doe

*Your Logo*

November 25, 2010

Dear Joe and Denise,

We have designed what we consider to be the perfect studio album. With the basic album design complete, you can review the image selection and design concept and modify it to suit your personality and taste. This saves you the worry and hassle of trying to design your heirloom album—after all, we have more design experience than most of our couples—but allows you to ensure that your album fulfills all of your expectations.

The following is a list of points to consider as you review your album design.

1. You may wish to call the office when you receive this package. It may be easier for us to walk you through all of your options over the telephone.
2. Keep in mind that our goal is to design a nontraditional album. We want to create a "storytelling album." Therefore, some of the images are required to tell the complete story of your day. You had a very unique and special story line, so more images were required to tell it. Because each album page has two sides, if you choose to eliminate the image(s) on one side of the page, you must also delete the image or images that appear on the reverse. Remember, the more photos you eliminate, the less likely people will be able to follow your unique story.
3. Our records indicate that you have a $1500 album credit. The total cost of the album, as we have designed it for you, is $3000. We require a 50% downpayment before we begin processing your order. It usually takes two to three months to complete the album design process, and the remaining balance will be due upon completion. Please make any additional changes as quickly as possible and fax or mail your requests to the studio.
4. If there are any additional images that need to be made, indicate the image numbers and complete an order form. We can be reached by phone, fax, or e-mail (1.800.123.4567, fax: 1.800.234.5678, or johndoe@YourtownPhotography.com) to discuss the details.

I look forward to hearing from you and I am sure you will be delighted with your album. The images look fabulous!

Sincerely,
John Doe

*Your Logo*

November 25, 2010

Dear Mary and James,

Hello . . . we hope married life finds you well. Congratulations again!

We are more than happy to help you with your album order needs. Just let us know what you decide about your product order as soon as possible to keep you in the system and prevent production delays. Please keep in mind it is not uncommon for us to design albums for out-of-town clients. With the number of destination wedding events we cover, it is very standard. Normally, if you were to visit the studio, you would review the album options, view your images, create a list of preferred shots, and then leave. We would then design an album and place a proof online for you to review and approve, or make changes as needed.

Since you will have a proofing CD and the images are available for online viewing, we can get the process started simply by following the steps below:

1. Pick an album (or confirm one they prepurchased). Album options can be viewed by visiting our website's product page at www.YourtownPhotography.com. Note that the amount due can be broken into payments, if desired. Album styles and sizes are as follows.

### 10x10- or 10x14-inch Album
*Premier*—200 images in any style album (magazine-style or classic design), $XXXX.00

*Deluxe*—150 images in any style album (magazine-style or classic design), $XXXX.00

*Basic Documentary*—75 images in any style album (magazine-style or classic design), $XXXX.00

*Traditional*—50 formal images in classic-style matted album, $XXXX.00

### 8x8-inch Album (Available with a Wide Variety of Mats)
*Premier*—A sixteen-page book with thirty-two color and black & white 5x7-, 4x6-, and 3x5-prints, $XXXX.00

*Deluxe*—A twelve-page book with twenty-four color 5x7-inch prints, $XXX.00

*Basic*—An eight-page book with sixteen color 5x7-inch prints, $XXX.00

2. Submit a list of preferred images via e-mail. Please visit www.JeffHawkins.com, go to Ordering, and click on your name. Your password is your six-digit wedding date (no hyphens). Images are visible online for thirty days (complimentary), so reference your proofing CD if necessary.

   When designing your album, you have two options: you can view the images and make a list of the photos you want in your album, then have our design team lay the album out for you, or you can create a list of the images you never want to see again. When choosing the first option, couples tend to limit their selections, often creating a scrapbook instead of a storybook. Selecting the second option allows us to create what we consider the perfect studio album. We have a long history of experience in album design, so you can expect an artfully designed album. Of course, once we have begun the design process, you can modify it to fit your personality and personal preferences.

3. Keep in mind that nontraditional albums are our specialty. We want to create a storybook. Therefore, some of the images that, by themselves, may not "make sense" are required to tell the complete story of your day. Also, note that the images have yet to be cropped and color corrected, and special effects may be added if needed. The images that appear online and on the CD are simply proofs.

4. Wait for your album proofing notification, then approve the design or request modifications if needed.

We can be reached at 407-834-8023 or 1-800-822-0816 if you wish to discuss the details of the design. I look forward to hearing from you, and I am sure you will be delighted with your album. The images look fabulous! Don't delay! We have been extremely busy since the first of the year and need to keep you in the system to avoid delay.

Sincerely,
John Doe

## ○ THE ALBUM DESIGN PROCESS

Once you have the couple's selected images list, the album design process can begin. When it comes to designing albums, many photographers get caught up in the hype and excitement of the new magazine-style digital art books. Though these albums have a lot of finesse, they typically have a higher price tag for your clients. Because of the newness of the trend, the pizzazz of the product, and the higher profit, many photographers encourage their client to purchase the best digital album their studio has to offer. Though you are excited about the trendy designs, consider encouraging your clients to purchase a coffee-table narrative album (e.g., Montage Art Book by Art Leather) and a traditional/formal book in a matted classic-style album (e.g., Futura Album by Art Leather). When a client purchases two books for nearly the same price as one for the "best" coffee-table art books, their perceived value increases, and they are happy about their purchase. This allows them to tell the story without interruption and allows the formal portraits to be showcased in a classic style.

Therefore, rather than encouraging your clients to purchase the best digital album level, consider having an incentive for purchasing a "good" or "better" narrative book and a "good" or "better" traditional album. This

ONCE YOU HAVE THE COUPLE'S SELECTED IMAGES LIST, THE ALBUM DESIGN PROCESS CAN BEGIN.

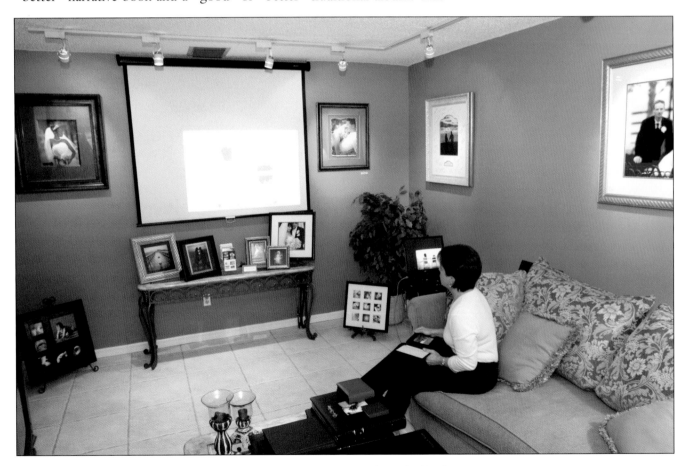

*Digital technology allows the album preview to be created, viewed, and edited on-screen.*

*The parents are typically more supportive of the contemporary-style album when the bride has the traditional/formal book to accompany it!*

increases their perceived value without drastically increasing the wholesale or retail investment. As a result, the parents are typically more supportive of the contemporary-style album when the bride has the traditional/formal book to accompany it!

### Benefits of Selling Storytelling Album Sets

- Your client's perceived value goes up, making them more likely to part with a larger percentage of their budget.
- You have more room to grow your albums after the wedding, by adding additional pages as the couple desires. Selling a "best" album leaves you with nowhere to grow. The couple is not likely to add a second album if they already prepurchased the biggest album you offer!
- Use a gift-with-purchase incentive to make double-volume sets more appealing!
- Consider offering the pocket-size duplicate album as a bonus with the digital narrative album. It is a fabulous PR piece and will definitely maximize your advertising dollars, as the bride will show it everywhere she goes!

With the changes in available products, there is a learning curve to creating these products with class. Consider the following helpful hints for designing digital-style storybooks:

*Montage Pro software facilitates the task of designing albums digitally, with beautiful results.*

1. Avoid panoramic prints—they make your pages more vulnerable. If you want a panoramic feel or look, simple create a panoramic spread in Photoshop and then cut the image down the middle and mount separately.

2. Create color harmony from page to page. Often studios are matching the backgrounds to the images and not taking into consideration that there should be design continuity from page to page.

3. Limit the number of images allowed on each page. We have found that an average of three to four images per page purchased creates an elegant appeal and keeps the focus on the images.

4. Set a limit on the number of collage pages! In the end, less is best!

5. Remember, just because you can, doesn't mean you should! Avoid too many graphics and special effects! Keep the focus on the photography.

6. Limit the number of verses and wording used in the book. Consider no more than one verse for eight pages purchased.

7. When grouping images, strive for an arrangement where each action has a reaction. For instance, pair a photo of the bride dancing with her dad with a photo of the bride's mom crying.

8. Use the bookend concept to lead the viewer's eyes across the page. Bookending simply means making sure each image "looks in" toward the spine of the album, like bookends. This leads the viewer's gaze into the center of the pictures and not outward off the page.

9. Use setup shots to lead the viewer to the next event. During the wedding, keep an eye open for images to use as setup shots that tell the viewer that something is about to change. For instance, an image of the church can be used to introduce the part of the album devoted to the ceremony, a photo of the cake can introduce the reception segment, etc.

10. Separate the storytelling images from the formal ones by inserting a closing image that marks a shift in the focus of the design. A shot of the couple waving goodbye, for instance, can signal the end of the wedding story and the beginning of the traditional, posed images.

Regardless of what style of storytelling you are capturing or what style album you select, an image of a person or of a family group is a symbol of a life that will eventually end. One never knows how important the next photograph will become. Photographs help us recall and share precious memories of the times, the events, and the people in our lives—even those that are long gone. There is no better way to document these memoirs than

*and they lived* *happily* *ever after!*

*December 30th 2004*

a narrative style. Use your gift to capture every tiny detail, every smile, every tear. Life is precious, and what is here today can be gone tomorrow. Use the tools of the trade to preserve the memories!

## ○ TRIAL CLOSES

Throughout the album design process, remind the clients of the importance of a unique storytelling book. While you are designing it, recommend particular images and ask trial close questions. Always ask a *minimum* of five trial questions per design. These pre-close questions can include:

- Are you beginning to see the importance of using these detailed images to tell the story of your day?
- How do you like it so far?
- Isn't this wonderful? Wow, it looks incredible!
- Isn't it exciting to see the story unfold?
- Aren't you excited about showing your storybook to someone who couldn't be there with you and having them relive your day?
- Do you see how this fits together?
- Don't you just love that series of images?

*In designing a wedding album, strive for an arrangement where each action has a reaction.*

Educate your client on the storytelling process throughout the album design phase. Each time they answer yes to one of your pre-close questions, they are closing the sale themselves. If they object to the album upon completion, you will know it is strictly a financial objection. Throughout the design process, you should make statements such as, "We want you to have the perfect album. It is a family heirloom and will be with you for a lifetime. We want it to be exactly the way you want it. I am here to help you any way I can. Let's just focus on making this perfect for both of you."

Once you have designed a perfect album using setup shots, bookending techniques, and action/reaction images, it is time to begin finalizing the

design. You may want to suggest that the couple separate the formal section of their album from the storybook section. The only added cost is for an additional cover, and this separation will facilitate viewing the album.

There was a time when people needed to be sold and to have their objections overcome. Today, people will continue to do business with people they trust and like. When it comes to designing an album, do not push your clients too far out of their comfort level. Offer options, but don't persist to the point they become uncomfortable. If you create a product they like and read the pulse of the group, the images will sell themselves, and the album upgrades will happen. Use the technology available to help your sales presentations and your images will be enhanced, your albums will grow, and your sales will increase. Design price tags for your products and merchandise your way to profits. After consulting with numerous studios, several photographers mentioned having trouble selling larger albums and framed images. However, we noticed it was often difficult to tell what was available for sale and what was simply used to showcase the photographer's work. A client may be intrigued by what you have available but may be too intimidated to find out if it is in their budget. Merchandising your products will put your clients in a shopping mood and take the intimidation out of the process! Consider the following tips:

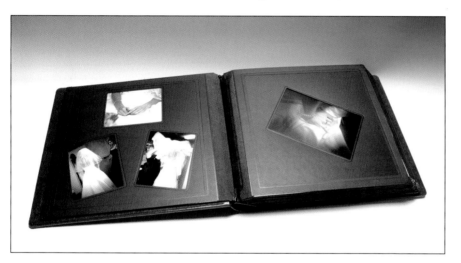

*Keep album samples available and current.*

1. Create quality price tags for your products. In albums, consider using parchment paper and clear contact paper to price your products. For frames, consider ordering engraved tags that mount to the wall. These are only a few dollars each. Be sure to keep your prices current, and add the expense to your yearly budget.

2. Leave some of your frames empty, so clients know they are available for immediate purchase. Add parchment paper inside the frame with a logo and a price tag.

3. Keep all product samples fresh. Order a new sample album from each product style to display and replace your framed prints annually. Don't become emotionally attached to your products or couples on displays. Your work should stay fresh and your samples current. Don't be fooled—brides can look at a style and tell how old an image is!

4. Remove your old albums from a viewing area (but keep them, just in case you ever need to reference it for a client).

## ○ FOCUS ON FRAMES

Framed work is artwork, and art sells! A studio profits the most from frame sales when marketing the frames from the beginning of the relationship with the couple. Using a complimentary engagement session can boost your frame sales before the wedding day; it is a great way to heighten your company's profits. Shortly before the wedding (and immediately after), each dollar is usually budgeted. This means the client is less likely to buy in high volume at these times. If you can arrange an engagement portrait well in advance of the wedding, you'll catch your clients when they have the most cash, the least amount of stress, and the most enthusiasm!

Once you have taken the portrait (regardless of whether it is an engagement portrait, formal bridal portrait, or wedding-day portrait) show your work in the frames you want to sell when the couple comes in to

SHOW YOUR WORK IN THE FRAMES YOU WANT TO SELL WHEN THE COUPLE COMES IN TO DESIGN THEIR ALBUM.

*Showing the couples photos in frames can help increase your profits.*

*Maximize your frame sales by show-ing a variety of samples that clients can easily browse.*

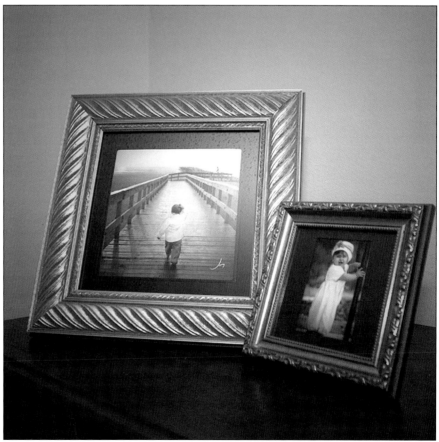

design their album. You may also consider e-mailing or mailing the parents of the couple a picture of a recommended framed image to promote sales to them as well. This can easily be accomplished by using Gross National Products' FrameWorks software. Not only will your images be showcased in style, but you will be encouraging your clients to buy custom-framed images instead of single prints for Mom and Grandmother. These are gifts that will

last a lifetime and won't end up in someone's kitchen drawer, waiting on a frame.

In order to successfully increase your frame sales, rethink the setup and display areas of your studio. Ask yourself the following questions:

1. Are you displaying your images in the frames you want to sell?
2. Do your custom-framed images have price tags on them? When touring a client, are you just selling your work, or are you selling your work in frames?
3. Are your studio samples outdated?
4. Are you showcasing frame samples that will appeal to all markets (traditional cherry, classic gold/silver, contemporary black, etc.)?
5. Do you change your prints and replace any old frame styles at least once a year?

When selecting a framing company, look for one that provides an impressive high-class image. In addition to the FrameWorks software, one of the benefits we appreciate the most is the fact that all the frames come in nice white presentation boxes, which increases the perceived value of the product upon delivery. See www.GNPframes.com for more information.

To optimize your frame sales, you must make an investment, because this is a case where the eye buys. You need to have samples to show in order to make the sale. If your studio gallery is large enough to show everything without seeming overcrowded, you are more likely to appeal to a wider audience. Upgrade your frames regularly. A poorly constructed or outdated frame can be detrimental to your otherwise fabulous image.

**Selling Points.** Begin each proofing process with a printout of your "good," "better,"and "best" framing options. Notate on every printout the price of each frame. Typically, we showcase a 20x24-inch frame with two vertical wall folios as our "best" suggestion, a single 16x20-inch framed print as a "better" option, and a 11x14-inch framed portrait as a "good" option. However, we do make notes when meeting with the client for the initial presentation as to what styles appeal to them, and we make selections based on their answers. On several instances, I have actually had clients buy *all* of the suggested items and not just one of the "good," "better," "best." In the past, I would have stopped suggesting after selling the large frame and the two wall folios, and our studio would have lost out on hundreds of dollars in sales.

When selling frames, ask your couples questions such as:

• What is your décor like?
• Where will people view your images?
• How will the image(s) be displayed on a desk or a wall?

*You can use FrameWorks software to show your clients what their images will look like in a variety of framing options—from a traditional single frame to a folio.*

*For clients not interested in purchasing large prints, suggest a small folio, which can showcase smaller images and encourages the sale of multiple images.*

Try to sell your clients on the concept of harmonizing framed images with their furniture and décor. Frames are not considered expensive if they are looked at as wall furniture. Use FrameWorks and ProSelect presentation and sales software to help them visualize the size of the image and what it will look like hanging on their wall. This will build the perceived value of their purchase.

**Pricing.** It is important to establish a pricing structure for all your framed images. 4x5-, 5x7-, 8x10-, and 10x10-inch prints may be purchased one by one at a fixed price. However, all prints 11x14 inches or larger should be priced as a custom-framing job. Taking control of framing helps you determine how your work will be showcased. If a client resists the already-framed pricing structure and wants a quote for an unframed image, try responding as follows:

> We can't guarantee the image if you have it framed elsewhere. This is due to the fact that mounting the print against cheap material can adversely affect it. If we frame the image, it will be done properly. If something should happen to the print because of the way it is protected, it will be replaced. You cannot afford not to have your print protected.

**Frame Promotions.** Consider increasing frame sales by creating promotions for the grandparents, parents, and bridal party. Target these parties directly by having your couples complete a wedding worksheet indicating the names and addresses of their maid of honor, best man, and parents. Currently, people are investing less in professional parent albums. They want quick results and do not want to spend hours pouring through a child's wedding album. Promoting a wall folio or custom-framed image allows them to appreciate the event every day as they pass by the area where it is displayed.

We have found that the easiest way to promote the framed images to relatives is by using Marathon Press's Client Connections software. With this software, you can customize a greeting card that incorporates an image from their child's event. On that greeting card, you can customize a frame special offer specifically created for the client. This is easy to do, and it creates a follow-up that increases the quality of your customer service and gets your studio's name in front of the prospect one more time. For more information, visit www.MarathonPress.com.

## ○ ONLINE ORDERING

You can further increase your sales by instituting an online ordering program. Because the couple's images can be accessed by their friends and family around the world, this will increase the flow of traffic onto your site and increase outside orders. Since this option provides a service to the couple

TAKING CONTROL OF FRAMING HELPS YOU DETERMINE HOW YOUR WORK WILL BE SHOWCASED.

(reducing their effort in showing proofs to everyone who wants to order photos), you should consider charging clients for placing the proofs online. Set a price for engagement proofs and charge an additional amount for posting wedding photos. We suggest that photographers select number of images, choose the prints, and determine the length of online visibility. The cost of online proofing is minimal, and the response can be incredible. (For additional information on this topic, go to www.EventPix.com, www.MarathonPress.com, and/or www.MorePhotos.com.)

Our wedding couples can view all of their images online for up to thirty days following the date of the event—free of charge. However, the "list price" of the service is shown in our pricing packet to increase the client's perceived value of our products and services.

*Online ordering allows clients—and their families and friends—to order images from the comfort of their home, no matter the distance. Needless to say, this can have a positive impact on your studio's profits.*

At the reception, the couple can display a special tabletop thank-you card with instructions for entering a password and viewing the proofs. We supply the cards at no cost, and the password is always the couple's six-digit wedding date.

Any guest who orders images online within the first thirty days receives 10 percent off portrait prices. This discount is easily applied using the www.MorePhotos.com discount ordering feature.

## O PUBLICITY=PROFITS

Keep the ball rolling and the publicity flowing! You have worked with your clients full circle to give them high-quality service in an expedited fashion. Now, you can keep the promotions flowing and maintain customer service to develop a client base that will continue to request your services for a lifetime. Use the following procedure to ensure you take every opportunity to connect with your clients and generate additional sales.

1. Immediately following the wedding, send thank-you notes to the key players (typically the bridal couple and their parents).
2. Always send anniversary cards.

3. Don't forget the holidays! Hold a Christmas family portrait special, conduct a Mother's Day parent album special, or a Father's Day folio promotion.
4. Don't forget about your wedding vendor contacts—send out complimentary engagement portrait session cards for Valentine's Day.

Pictured below are two promotional mailers we've used to increase publicity and build sales. Try to develop a variation that suits your business!

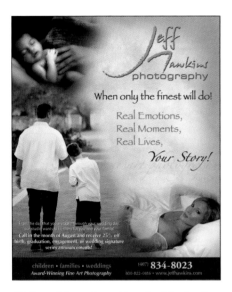

*Using Marathon Press's Marketing Partnership postcard mailing program, it is easy to design and create mailings to generate new clients or to retain the old ones as your client's family grows. Be sure that all of your magazine ads feature similar fonts, wording, and hues , This will help to establish brand recognition.*

*Your employees play an important role in attracting—and satisfying—clients.*

## ○ TEAMWORK

As the saying goes, there is no "I" in "team." Strength comes in unity. Consider hiring production, technical, office, marketing, and photography assistants to help complete the cycle.

See the following job descriptions to determine which positions (and help in which phase of the cycle) will best assist you in your endeavors. Though the number of employees and the duties performed by each will vary greatly based on the size of the business, the location, and the marketing demographics, these positions are all very valuable.

**Employee Guidelines.** For employees who will work in a residential setting, it is especially important to set guidelines such as these. Of course, yours will be tailored to the unique needs of your business.

*Employee Etiquette.* All employees are required to maintain professionalism while conducting the required duties as stated in the appropriate job description. Emphasis on team interaction is required.

*Dress Code.* Casual but professional attire is required at all times. Even if a given position doesn't require continuous contact with people, professional attire should be maintained. Keeping in line with the team interaction concept, all employees should be able to assist with customers as deemed appropriate by management and maintain the image established by Yourtown Photography. Shorts and jeans should be avoided. Dress slacks, khakis, dresses, and skirts are preferred. Hair should be neatly groomed. Because of our close working conditions, perfume should be kept to a minimum. If attire is a concern, Yourtown Photography shirts can be provided to be worn with black dress slacks or khakis.

*Scheduling.* Yourtown Photography will work with your schedule when possible. Nevertheless, we do require an established schedule. Please notify us of any schedule changes within twenty-four hours of the start of your

shift. Furthermore, schedule modifications should be established with the approval of management as far in advance as possible.

*Time Sheets.* Please use the studio management software to track your schedule. Punch in upon arrival and out for each break. Any unethical practices involving time will result in immediate termination. Paychecks will be distributed every other Friday.

*Phone Etiquette for Residential Business.* When available, the owners will most likely answer the phone calls. However, if we are occupied, your assistance is required. Please keep in mind that because we have a home-based business, your schedule may not always be the same as ours. Just because you are working does not mean that we are working. If we are not in the office, we are not available. When the production and technical assistants are working together, the production assistant should answer the phone.

### Don'ts

- Never reveal to a client anything personal (e.g., so-and-so is in the shower, taking a nap, exercising, etc.). That is irrelevant and is none of the caller's business!
- Never give a prospective client prices over the phone.
- Never give someone our cell phone number if they want wedding photography information or wish to schedule an appointment. Simply take down their message.

### Do's

- Be sure to answer the phone with, "Good afternoon, Yourtown Photography, can I help you?" If the person they wish to speak to is available, please say, "May I ask what this is in regards to?" If the person is unavailable, please say, "I'm sorry, he/she is unavailable at the moment. May I take a message and have him/her get right back to you?"
- Take a detailed message on a message pad. Call our cell phone if you feel an issue needs to be addressed quickly.
- Be friendly, courteous, and professional.
- Keep personal phone calls to a minimum.
- Push the hold button before talking to us about who is on the line.

On the following pages, you'll find sample forms that outline the responsibilities of the job titles held by employees at our studio.

*Top-notch customer service is the first step to excellent images and huge orders.*

# Position: Marketing Director

Hours: Minimum 30 hours per week required
Reports to: John Doe, owner

Duties include:

1. Pose as the primary public relations representative
2. Coordinate all correspondence with prospective clients
3. Schedule interviews
4. Follow up with all e-mail correspondence and inquiries
5. Conduct client interviews
6. Bridal show liaison (work bridal show exhibits and follow up with leads)
7. Attend networking functions
8. Initiate vendor referral
9. Create company press releases
10. Launch yearly promotions and contests
11. Establish a bridal follow up program
12. Schedule client album design sessions
13. Oversee activity of the production, technical, and office assistants
14. All other duties as deemed appropriate and specified by owner

I accept all the above duties and job requirement and will fulfill them to the best of my abilities. I realize it requires a team effort to conduct the mission of Yourtown Photography and will display a team spirit and professional attitude and image.

Employee signature _____

Date _____

# Position: Production Assistant*

Hours: Minimum 15 hours per week required
Reports to: Jane Doe, director of operations
Oversees activities: John Doe, owner

Duties include:

1. Production assistant is required to work closely with the technical assistant
2. Prep proofs, verify numbering
3. Pull orders, send to lab, verify corrections
4. Document the status of all orders in the computer
5. Periodically double-check the status of orders
6. Assemble albums
7. Notify director of operations when orders and albums are complete and ready for pickup
8. Update and order mats
9. Fax album order to supplier
10. Assemble interviewing packets
11. Keep client status forms up-to-date
12. Prepare thank-you notes for clients after their album is complete
13. Answer the phones and doors, and assist with clients when necessary
14. Take turns with technical assistant to empty trash at end of day
15. File Yourtown Photography receipts
16. Place completed order folders on top shelf in closet
17. Place single orders on the shelf on the left of closet
18. Monitor airborne shipping, send orders daily
19. All other duties as deemed appropriate and specified by the director of operations or the owner

*Please bear in mind the technical assistant and the production assistant positions are designed to be a job-sharing position. Duties and positions may be switched to create a cross-training program within the organization.

I accept all the above duties and job requirements and will fulfill them to the best of my abilities. I realize it requires a team effort to conduct the mission of Yourtown Photography and will display a team spirit and professional attitude and image.

Employee signature _____

Date _____

# Position:
# Technical Assistant*

Hours: Minimum 15 hours per week required

Reports to: Jane Doe, director of operations

Oversees activities: John Doe, owner

Duties include:

1. Work closely with the production assistant
2. Pull client folder or create one if necessary
3. Begin client status sheet and oversee completion
4. Organize images when orders are returned from lab
5. Create three client preview videos, labels, and covers
6. Print labels for preview videos, promotional videos
7. Create album design layout
8. Retouch images and prep for production
9. Copy promotional videos
10. Print Yourtown Photography labels and lab identification labels
11. Take turns with the technical assistant to empty trash at end of day
12. Place completed order folders on top shelf in closet
13. Place single orders on the shelf on the left of closet
14. Answer the phones and doors
15. Assist with clients when necessary.
16. All other duties as deemed appropriate and specified by the director of operations or the owner

*Please bear in mind the technical assistant and the production assistant positions are designed to be a job-sharing position. Duties and positions may be switched to create a cross-training program within the organization.

I accept all the above duties and job requirements and will fulfill them to the best of my abilities. I realize it requires a team effort to conduct the mission of Yourtown Photography and will display a team spirit and professional attitude and image.

Employee signature _____

Date _____

# Position: Wedding Photography Assistant*

Hours: Weekend, wedding hours required

Reports to: John Doe, owner

Oversees activities: Jane Doe, director of operations

Duties include:

1. The photography assistant is required to work closely with the photographer and the personal bridal assistant
2. Assist in maintaining a positive professional image on the day of the wedding, while providing adept customer service and, thus, effective public relations
3. Inventory and organize equipment, maintain site and equipment control on location
4. Responsible for metering lights
5. Load film backs
6. Set up auxiliary lights
7. Assist in coordinating formal portraiture
8. Examine and assist with details of posed images (i.e., bride's dress, flowers, etc.)
9. Pack, load, and unload equipment
10. All other duties as deemed appropriate and specified by the director of operations or the owner

*Please bear in mind the photography assistant works in a triangular fashion along with the technical assistant and the production assistant; this designed to be a job-sharing position. Duties and positions may be switched to create a cross-training program within the organization.

I accept all the above duties and job requirements and will fulfill them to the best of my abilities. I realize it requires a team effort to conduct the mission of Yourtown Photography and will display a team spirit and professional attitude and image.

Employee signature _____

Date _____

# FINAL THOUGHTS

*Wedding photography is a privilege. You are documenting a very important part of your clients' lives and becoming a very important part of their future.*

A wise woman once shared the golden philosophy of life. She said that in every situation, you have three options: fix it, live with it, or get out of it. When examining your business, we challenge you to evaluate this golden philosophy. Fix it and make your business better, live with it and accept things for how they are and how they will always be, or get out of it and become a part of something you love.

Wedding photography is a privilege. You are documenting a very important part of your clients' lives and becoming a very important part of their future.

As wedding photographers, our mission is to maintain outstanding public relations and excellent customer service while attempting to capture a superior bridal market. Our goal is to photograph and immortalize the special moments in the lives of discerning couples. We believe photography is one of the most important aspects of their entire wedding day.

Now that you've started down the path, take a few minutes to look at the questionnaire on the following page. If you can't sincerely answer "true" to every question, work harder to improve those areas. Check back regularly to ensure that (from a client's point of view) you are doing everything you can to win clients and keep their business for life.

We hope this book helps you follow your mission, your passion, and your dreams.

Take a moment to step back and view your business from your client's point of view. Answer "true" or "false" to the following questions.

T/F   My photographer always delivers my product in a timely manner.

T/F   My photographer introduces me to new products regularly.

T/F   My photographer calls me regularly, and returns my calls promptly.

T/F   My photographer sends me an anniversary card every year.

T/F   My photographer sent me a thank-you card for my business.

T/F   I get a newsletter or notice of seasonal promotions from my photographer.

T/F   My photographer always looks professional when I do business with him/her.

T/F   My photographer has offered to conduct family and baby portraits.

T/F   I feel confident referring my friends to my photographer.

T/F   My photographer is passionate and enthusiastic about his/her work.

T/F   My photographer has high ethical standards. His word is his bond.

T/F   My photographer provides me with good customer service and makes me feel special.

How did you rate? All of these questions demand a "true" response. If your response to any of the above statements was "false," then take a moment to consider the steps you need to correct the particular problem or oversight.

*There's a lot riding on your ability to nurture your relationship with your clients. Making sure that you can anticipate your clients' needs will help to ensure a lifelong relationship.*

# ABOUT THE AUTHORS

*Author photos courtesy of Jeff Hawkins Photography.*

Jeff and Kathleen Hawkins are proud to operate a fully digital high-end wedding and portrait photography studio in Longwood, Florida. Together as a team, they are proud to be the authors of *Professional Techniques for Digital Wedding Photography* (2nd Ed.; Amherst Media, 2004).

Industry sponsored, they are both very active in the photography speaking circuit and take pride in their impact in the industry and in the community. Jeff Hawkins is a Certified Professional Photographer and holds a Photographic Craftsman degree. He has been a professional photographer for over twenty years.

Kathleen Hawkins also holds her Photographic Craftsman Degree and earned a Masters in Business Administration. She previously taught business courses for a Florida university. She has also authored several books, all published by Amherst Media: *The Bride's Guide to Wedding Photography* (2003), *Digital Photography for Children's and Family Portraiture* (2004), *Marketing & Selling Techniques for Digital Portrait Photography* (2005), and *The Parent's Guide to Photographing Children and Families* (2005).

*Photographers are blessed with an important task: to chronicle for the bride and groom the joy and unique character of their special day. It's both an important responsibility and a privilege.*

# INDEX

*Also by Jeff and Kathleen Hawkins . . .*

PROFESSIONAL TECHNIQUES FOR
**DIGITAL WEDDING PHOTOGRAPHY**, 2nd Ed.
From selecting equipment, to marketing, to building a digital workflow, this book teaches how to make digital work for you. $29.95 list, 8½x11, 128p, 85 color images, order no. 1735.

*Also by Kathleen Hawkins . . .*

**THE BRIDE'S GUIDE TO WEDDING PHOTOGRAPHY**
Get the wedding photography of your dreams with tips from the pros. Perfect for brides (or photographers preparing clients for their photography). $14.95 list, 9x6, 112p, 115 color photos, index, order no. 1755.

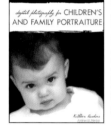

**DIGITAL PHOTOGRAPHY FOR CHILDREN'S AND FAMILY PORTRAITURE**
Discover how digital photography can boost your sales, enhance your creativity, and improve your studio's workflow. $29.95 list, 8½x11, 128p, 130 color images, index, order no. 1770.

**MARKETING & SELLING TECHNIQUES**
FOR DIGITAL PORTRAIT PHOTOGRAPHER
Great images aren't enough to ensure a successful business! Learn to attract clients and boost sales. $34.95 list, 8½x11, 128p, 150 color photos, index, order no. 1804.

THE PARENT'S GUIDE TO
**PHOTOGRAPHING CHILDREN AND FAMILIES**
Are you the designated photographer in your family? Learn how to improve your results and create images that will be treasured forever! $14.95 list, 6x9, 96p, 110 color photos, index, order no. 1904.

**GROUP PORTRAIT PHOTOGRAPHY HANDBOOK**, 2nd Ed.
*Bill Hurter*
Featuring over 100 images by top photographers, this book offers practical techniques for composing, lighting, and posing group portraits—whether in the studio or on location. $34.95 list, 8½x11, 128p, 120 color photos, order no. 1740.

**THE BEST OF WEDDING PHOTOGRAPHY**, 2nd Ed.
*Bill Hurter*
Learn how the top wedding photographers in the industry transform special moments into lasting romantic treasures with the posing, lighting, album design, and customer service pointers found in this book. $34.95 list, 8½x11, 128p, 150 color photos, order no. 1747.

**THE BEST OF CHILDREN'S PORTRAIT PHOTOGRAPHY**
*Bill Hurter*
*Rangefinder* editor Bill Hurter draws upon the experience and work of top professional photographers, uncovering the creative and technical skills they use to create their magical portraits of these young subejcts. $29.95 list, 8½x11, 128p, 150 color photos, order no. 1752.

**WEDDING PHOTOGRAPHY WITH ADOBE® PHOTOSHOP®**
*Rick Ferro and Deborah Lynn Ferro*
Get the skills you need to make your images look their best, add artistic effects, and boost your wedding photography sales with savvy marketing ideas. $29.95 list, 8½x11, 128p, 100 color images, index, order no. 1753.

**WEB SITE DESIGN FOR PROFESSIONAL PHOTOGRAPHERS**
*Paul Rose and Jean Holland-Rose*
Learn how to design, maintain, and update your own photography website—attracting new clients and boosting your sales. $29.95 list, 8½x11, 128p, 100 color images, index, order no. 1756.

## PROFESSIONAL PHOTOGRAPHER'S GUIDE TO
## SUCCESS IN PRINT COMPETITION

*Patrick Rice*

Learn from PPA and WPPI judges how you can improve your print presentations and increase your scores. $29.95 list, 8½x11, 128p, 100 color photos, index, order no. 1754.

## PHOTOGRAPHER'S GUIDE TO
## WEDDING ALBUM DESIGN AND SALES

*Bob Coates*

Enhance your income and creativity with these techniques from top wedding photographers. $29.95 list, 8½x11, 128p, 150 color photos, index, order no. 1757.

## THE BEST OF WEDDING PHOTOJOURNALISM

*Bill Hurter*

Learn how top professionals capture these fleeting moments of laughter, tears, and romance. Features images from over twenty renowned wedding photographers. $29.95 list, 8½x11, 128p, 150 color photos, index, order no. 1774.

## THE DIGITAL DARKROOM GUIDE WITH ADOBE® PHOTOSHOP®

*Maurice Hamilton*

Bring the skills and control of the photographic darkroom to your desktop with this complete manual. $29.95 list, 8½x11, 128p, 140 color images, index, order no. 1775.

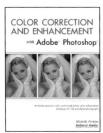

## COLOR CORRECTION AND ENHANCEMENT WITH ADOBE® PHOTOSHOP®

*Michelle Perkins*

Master precision color correction and artistic color enhancement techniques for scanned and digital photos. $29.95 list, 8½x11, 128p, 300 color images, index, order no. 1776.

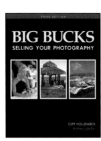

## BIG BUCKS SELLING YOUR PHOTOGRAPHY, 3rd Ed.

*Cliff Hollenbeck*

Build a new business or revitalize an existing one with the comprehensive tips in this popular book. Includes twenty forms you can use for invoicing clients, collections, follow-ups, and more. $17.95 list, 8½x11, 144p, resources, business forms, order no. 1177.

## POWER MARKETING FOR WEDDING AND PORTRAIT PHOTOGRAPHERS

*Mitche Graf*

Set your business apart and create clients for life with this comprehensive guide to achieving your professional goals. $29.95 list, 8½x11, 128p, 100 color images, index, order no. 1788.

## POSING FOR PORTRAIT PHOTOGRAPHY
### A HEAD-TO-TOE GUIDE

*Jeff Smith*

Author Jeff Smith teaches surefire techniques for fine-tuning every aspect of the pose for the most flattering results. $29.95 list, 8½x11, 128p, 150 color photos, index, order no. 1786.

## DIGITAL INFRARED PHOTOGRAPHY

*Patrick Rice*

The dramatic look of infrared photography has long made it popular—but with digital it's actually *easy* too! Add digital IR to your repertoire with this comprehensive book. $29.95 list, 8½x11, 128p, 100 b&w and color photos, index, order no. 1792.

## THE BEST OF DIGITAL WEDDING PHOTOGRAPHY

*Bill Hurter*

Explore the groundbreaking images and techniques that are shaping the future of wedding photography. Includes dazzling photos from over 35 top photographers. $29.95 list, 8½x11, 128p, 175 color photos, index, order no. 1793.

## INTO YOUR DIGITAL DARKROOM STEP BY STEP

*Peter Cope*

Make the most of every image—digital or film—with these techniques for photographers. Learn to enhance color, add special effects, and much more. $29.95 list, 8½x11, 128p, 300 color images, index, order no. 1794.

## WEDDING AND PORTRAIT PHOTOGRAPHERS' LEGAL HANDBOOK

*N. Phillips and C. Nudo, Esq.*

Don't leave yourself exposed! Sample forms and practical discussions help you protect yourself and your business. $29.95 list, 8½x11, 128p, 25 sample forms, index, order no. 1796.

## PROFITABLE PORTRAITS
THE PHOTOGRAPHER'S GUIDE TO CREATING PORTRAITS THAT SELL

*Jeff Smith*

Learn how to design images that are precisely tailored to your clients' tastes—portraits that will practically sell themselves! $29.95 list, 8½x11, 128p, 100 color photos, index, order no. 1797.

PROFESSIONAL TECHNIQUES FOR
## BLACK & WHITE DIGITAL PHOTOGRAPHY

*Patrick Rice*

Digital makes it easier than ever to create black & white images. With these techniques, you'll learn to achieve dazzling results! $29.95 list, 8½x11, 128p, 100 color photos, index, order no. 1798.

DIGITAL PORTRAIT PHOTOGRAPHY OF
## TEENS AND SENIORS

*Patrick Rice*

Learn the techniques top professionals use to shoot and sell portraits of teens and high-school seniors! Includes tips for every phase of the digital process. $34.95 list, 8½x11, 128p, 200 color photos, index, order no. 1803.

## DIGITAL PHOTOGRAPHY BOOT CAMP

*Kevin Kubota*

Kevin Kubota's popular workshop is now a book! A down-and-dirty, step-by-step course in building a professional photography workflow and creating digital images that sell! $34.95 list, 8½x11, 128p, 250 color images, index, order no. 1809.

## PROFESSIONAL POSING TECHNIQUES FOR WEDDING AND PORTRAIT PHOTOGRAPHERS

*Norman Phillips*

Master the techniques you need to pose subjects successfully—whether you are working with men, women, children, or groups. $34.95 list, 8½x11, 128p, 260 color photos, index, order no. 1810.

HOW TO START AND OPERATE A
## DIGITAL PORTRAIT PHOTOGRAPHY STUDIO

*Lou Jacobs Jr.*

Learn how to build a successful digital portrait photography business—or breathe new life into an existing studio. $39.95 list, 6x9, 224p, 150 color images, index, order no. 1811.

## BLACK & WHITE PHOTOGRAPHY
TECHNIQUES WITH ADOBE® PHOTOSHOP®

*Maurice Hamilton*

Become a master of the black & white digital darkroom! Covers all the skills required to perfect your black & white images and produce dazzling fine-art prints. $34.95 list, 8½x11, 128p, 150 color/b&w images, index, order no. 1813.

## NIGHT AND LOW-LIGHT
TECHNIQUES FOR DIGITAL PHOTOGRAPHY

*Peter Cope*

With even simple point-and-shoot digital cameras, you can create dazzling nighttime photos. Get started quickly with this step-by-step guide. $34.95 list, 8½x11, 128p, 100 color photos, index, order no. 1814.

## MASTER COMPOSITION GUIDE FOR DIGITAL PHOTOGRAPHERS

*Ernst Wildi*

Composition can truly make or break an image. Master photographer Ernst Wildi shows you how to analyze your scene or subject and produce the best-possible image. $34.95 list, 8½x11, 128p, 150 color photos, index, order no. 1817.

## PROFESSIONAL STRATEGIES AND TECHNIQUES FOR DIGITAL PHOTOGRAPHERS

*Bob Coates*

Learn how professionals—from portrait artists to commercial specialists—enhance their images with digital techniques. $29.95 list, 8½x11, 128p, 130 color photos, index, order no. 1772.

LIGHTING TECHNIQUES FOR
## LOW KEY PORTRAIT PHOTOGRAPHY

*Norman Phillips*

Learn to create the dark tones and dramatic lighting that typify this classic portrait style. $29.95 list, 8½x11, 128p, 100 color photos, index, order no. 1773.

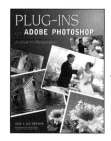

## PLUG-INS FOR ADOBE® PHOTOSHOP®
A GUIDE FOR PHOTOGRAPHERS

*Jack and Sue Drafahl*

Supercharge your creativity and mastery over your photography with Photoshop and the tools outlined in this book. $29.95 list, 8½x11, 128p, 175 color photos, index, order no. 1781

### THE PORTRAIT PHOTOGRAPHER'S
## GUIDE TO POSING
*Bill Hurter*

Posing can make or break an image. Now you can get the posing tips and techniques that have propelled the finest portrait photographers in the industry to the top. $29.95 list, 8½x11, 128p, 200 color photos, index, order no. 1779.

## MASTER LIGHTING GUIDE
### FOR PORTRAIT PHOTOGRAPHERS
*Christopher Grey*

Efficiently light executive and model portraits, high and low key images, and more. Master traditional lighting styles and use creative modifications that will maximize your results. $29.95 list, 8½x11, 128p, 300 color photos, index, order no. 1778.

## ARTISTIC TECHNIQUES WITH ADOBE® PHOTOSHOP® AND COREL® PAINTER®
*Deborah Lynn Ferro*

Flex your creative skills and learn how to transform photographs into fine-art masterpieces. Step-by-step techniques make it easy! $34.95 list, 8½x11, 128p, 200 color images, index, order no. 1806.

## THE BEST OF PHOTOGRAPHIC LIGHTING
*Bill Hurter*

Top professionals reveal the secrets behind their successful strategies for studio, location, and outdoor lighting. Packed with tips for portraits, still lifes, and more. $34.95 list, 8½x11, 128p, 150 color photos, index, order no. 1808.

### LIGHTING TECHNIQUES FOR
## FASHION AND GLAMOUR PHOTOGRAPHY
*Stephen A. Dantzig, PsyD.*

In fashion and glamour photography, light is the key to producing images with impact. With these techniques, you'll be primed for success! $29.95 list, 8½x11, 128p, over 200 color images, index, order no. 1795.

## CLASSIC PORTRAIT PHOTOGRAPHY
*William S. McIntosh*

Learn how to create portraits that truly stand the test of time. Master photographer Bill McIntosh discusses some of his best images, giving you an inside look at his timeless style. $29.95 list, 8½x11, 128p, 100 color photos, index, order no. 1784.

## PROFESSIONAL MODEL PORTFOLIOS
### A STEP-BY-STEP GUIDE FOR PHOTOGRAPHERS
*Billy Pegram*

Learn how to create dazzling portfolios that will get your clients noticed—and hired! $29.95 list, 8½x11, 128p, 100 color images, index, order no. 1789.

## THE MASTER GUIDE TO DIGITAL SLR CAMERAS
*Stan Sholik and Ron Eggers*

What makes a digital SLR the right one for you? What features are available? What should you look out for? These questions and more are answered in this helpful guide. $29.95 list, 8½x11, 128p, 180 color photos, index, order no. 1791.

### THE ART AND TECHNIQUES OF
## BUSINESS PORTRAIT PHOTOGRAPHY
*Andre Amyot*

Learn the business and creative skills photographers need to compete successfully in this challenging field. $29.95 list, 8½x11, 128p, 100 color photos, index, order no. 1762.